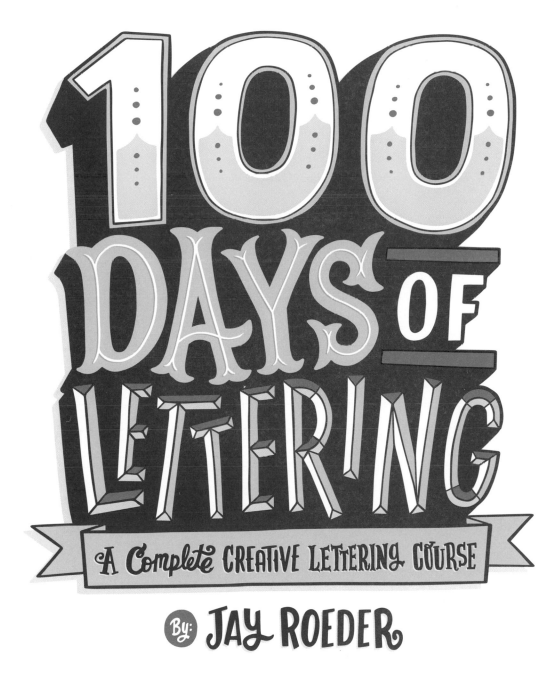

# 100 DAYS OF LETTERING

## A Complete CREATIVE LETTERING COURSE

By: JAY ROEDER

LARK

New York

New York

An Imprint of Sterling Publishing Co., Inc.
1166 Avenue of the Americas
New York, NY 10036

ISBN 978-1-4547-1073-8

Distributed in Canada by Sterling Publishing Co., Inc.
c/o Canadian Manda Group, 664 Annette Street
Toronto, Ontario M6S 2C8, Canada

For information about custom editions, special sales, and premium and corporate purchases, please contact Sterling Special Sales at 800-805-5489 or special sales@sterlingpublishing.com.

Manufactured in India

4 6 8 10 9 7 5

sterlingpublishing.com

Produced by BlueRed Press Ltd

Dedicated to my brothers:
# CHRIS & ANDY

# Table of CONTENTS

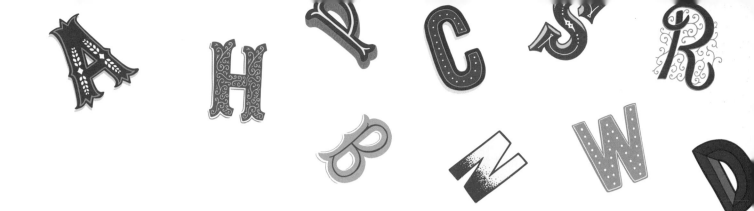

# INTRODUCTION

Hello there! My name is Jay Roeder and I'm completely psyched to share some of my thoughts on hand-lettering with you. Many years ago when I first started taking an interest in hand-lettering, there was little information readily available, and I had to establish my own workflow based on trial and error. My goal is to help you gain a quicker grasp of hand-lettering, all inside of 100 days!

*Jay Roeder*

# WHAT IS HAND-LETTERING?

**To explain it in simple terms, hand-lettering is the art of drawing letters as opposed to writing or typing them.**

From signs on the street to product labels, to national advertising campaigns, hand-lettering can be found almost everywhere if you just look. It can transform a simple line of communication into a beautiful work of art, and furthermore, convey a natural personal aesthetic. Each piece of hand-lettered artwork is one of a kind, made for a specific project or application.

A surprising amount goes into making hand-lettering look right. We use pens, pencils, brushes, and chalk to craft our artwork. This way each letter takes on its own character and does not display identically when drawn again, making it a very personal and unique discipline.

However, it is equally important to understand how hand-lettering differs from other commonly associated disciplines like typography and calligraphy. You are looking at typography right now—fonts set onto a page by a typographer. Notice how each repeating character is exactly the same? That's because a typographer uses a collection of prefabricated letters called fonts to create their compositions.

Calligraphy is based on penmanship and involves writing letters, as opposed to drawing them. A calligrapher uses a special pen or brush to create thick and thin lines using varying degrees of pressure.

Now that you know the differences between lettering disciplines you'll be able to seek out resources and speak the correct lingo!

# LETTEROLOGY

Have you ever thought about what distinguishes one letter style from the next? In order to properly discern these differences, it is important to familiarize yourself with a standardized set of terms commonly referred to as the "anatomy of letterforms." Once you know how to visually deconstruct a letter, it will be much easier to understand how that specific letter or alphabet was built-up and more importantly, how to create your own lettering styles. On this spread, you'll see a few of the more commonly used terms to help give you a quick crash course on letter anatomy.

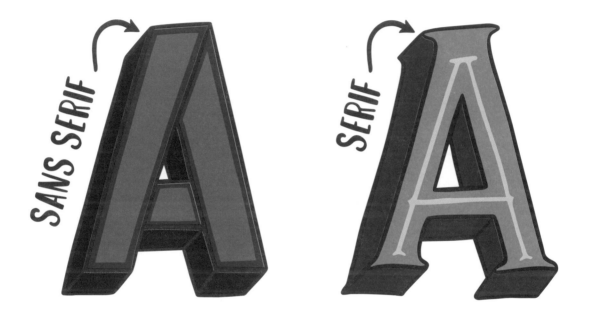

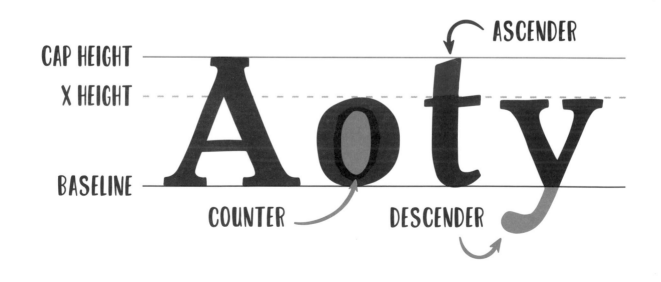

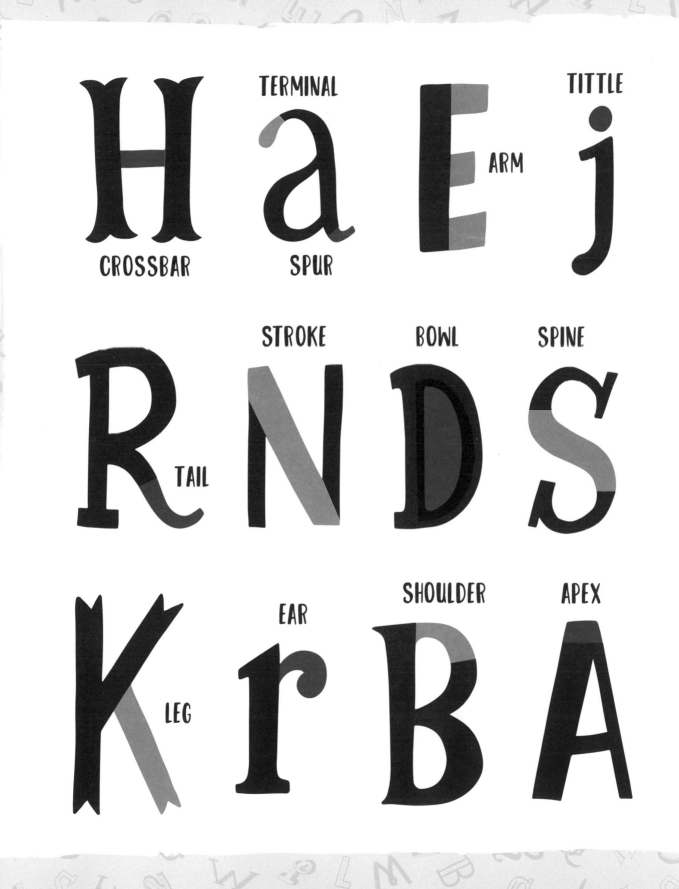

TERMINAL

TITTLE

ARM

CROSSBAR

SPUR

STROKE

BOWL

SPINE

TAIL

EAR

SHOULDER

APEX

LEG

# GETTING STARTED

Welcome to the hardest part—the start. Even professionals have to begin somewhere though, right? In this section you'll learn what tools to gather and how to get inspired and put them to use, along with a few inspirational tips. Don't worry, you've got this.

# TOOLS OF MASS CREATION

Hand-lettering can be a bit intimidating when you're first starting out, especially when it comes to selecting the right tools for the job. Thankfully, you don't need to spend a ton of money on supplies to begin. Always keep in mind: it's not the tool that makes the art, it's the artist. Here are seven essential and easy-to-find tools that I use to create hand-lettering artwork.

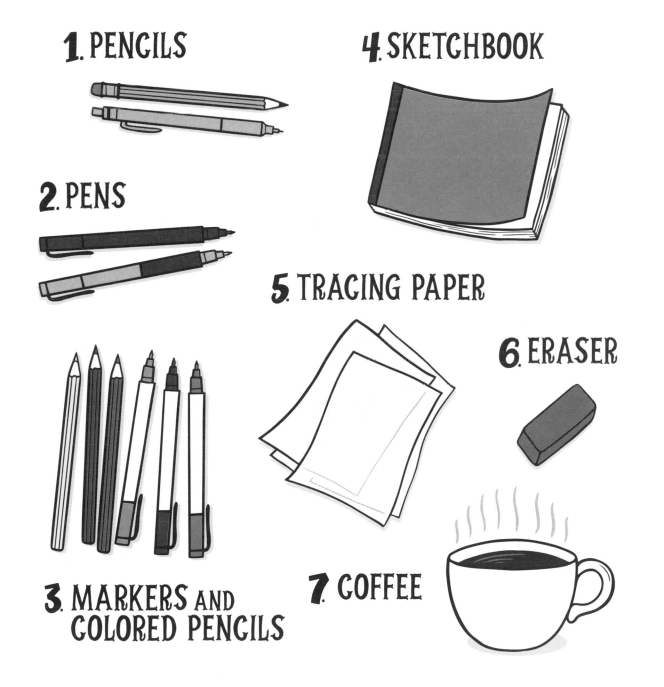

**1.** PENCILS

**2.** PENS

**3.** MARKERS AND COLORED PENCILS

**4.** SKETCHBOOK

**5.** TRACING PAPER

**6.** ERASER

**7.** COFFEE

# GET INSPIRED

Why are you interested in hand-lettering? Chances are you've been inspired by the work of another hand-lettering artist out there. Inspiration is the fuel behind any great work of art, across every discipline. It is what gets our creative juices flowing—it's why you're reading this book. Inspiration can be found everywhere. Inside and outside, in music and movies, in nature and in urban cityscapes—it is literally everywhere. When I first started hand-lettering, I was enthused by the works of many great artists and musicians, and from that inspiration I developed my own style through repetition. Remember, nothing is completely original, so find your inspiration, build on it and make it your own!

You Can't Buy Happiness But You Can Buy Ice Cream and that's basically the Same Thing

Never Give Up. Ever.

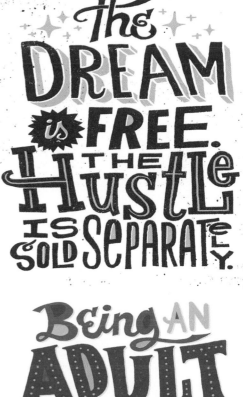

The Dream is Free. The Hustle is Sold Separately.

I Like to Party And by Party I Mean Take Naps

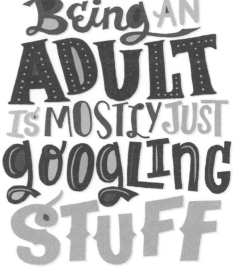

Being An Adult is Mostly Just Googling Stuff

I have Read and Agreed to the Terms and Conditions

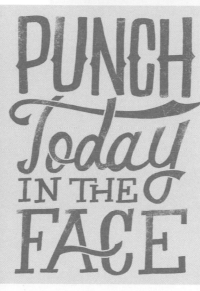

Punch Today In the Face

Fresh to Death

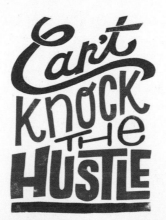

Can't Knock the Hustle

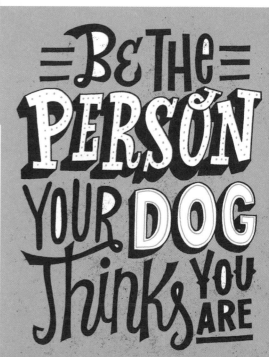

Be The Person Your Dog Thinks You Are

# BREAK THE RULES

I love describing my style as "embraced imperfection." As a perfectionist, it was not until I learned how to break the rules a little bit and accept the crooked lines, misaligned type, and illegibility that my lettering took on personality and interest. As odd as it sounds, these imperfections can have just as much craft as perfection. If you look at any great hand-lettering artist's work, you will see these "errors" are not accidents at all. That being said, break rules and have fun with your hand-lettering. Who cares if the lines aren't straight and the letters are a little crooked? Embrace those imperfections!

*Share your artwork with*
## #100 DaysOfLettering

Social media can be a very useful tool in gaining clients and exposure for your work. As you complete the exercises in this book, be sure to share your progress with the hand-lettering community by tagging each post with **#100DaysOfLettering**.

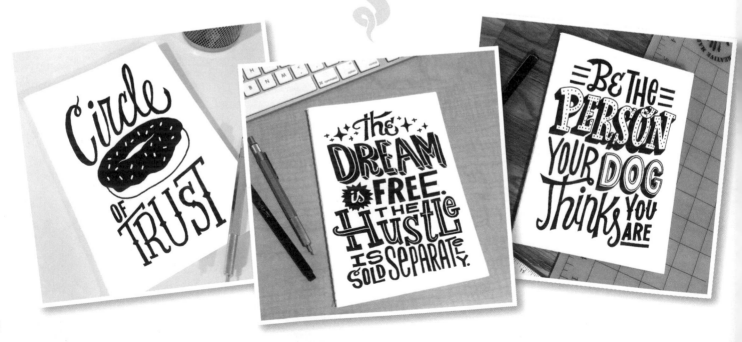

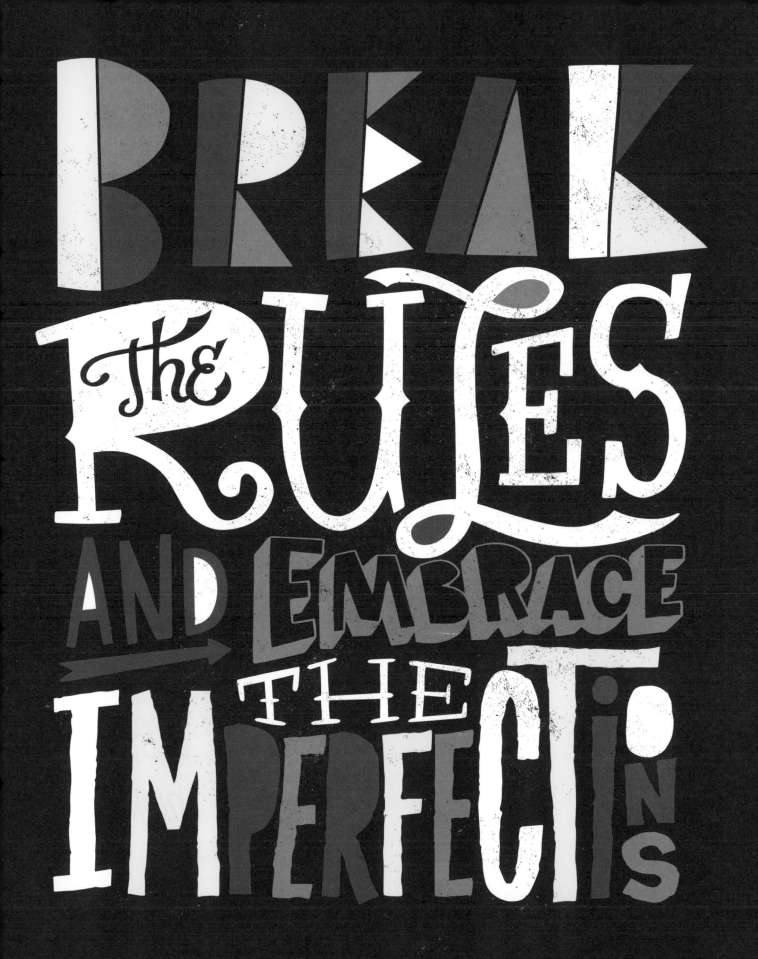

# Days 1–10
# THE PROCESS

When I first started hand-lettering, the toughest thing to establish was a proper workflow process. I had an idea of what I wanted my finished artwork to look like, but didn't know how to get there. Through lots of trial and error I have come up with a simple process to create my artwork. I am confident that this framework will help guide you in becoming a hand-lettering artist—so follow my rules!

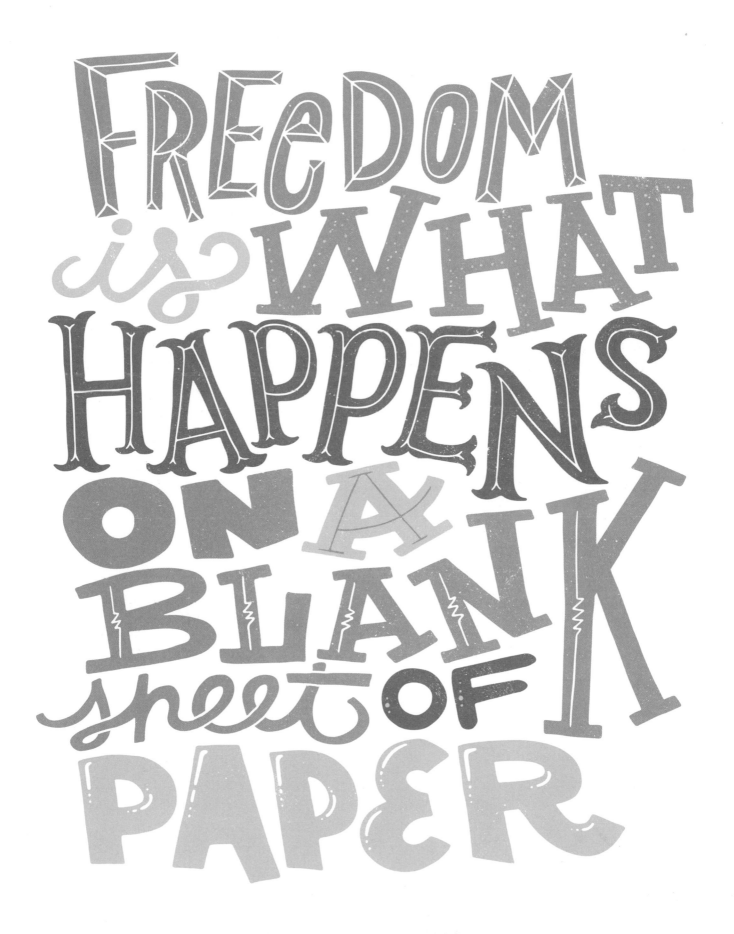

Inspiration comes unannounced. It is all around us in different forms, you just need to learn to recognize it. Reading books, traveling, and sharing conversation can influence art. Sometimes simply forcing yourself to sit down and sketch can bring out a great idea. I have found a lot of inspiration from music and personal experiences with friends and family members. Where do you find your inspiration?

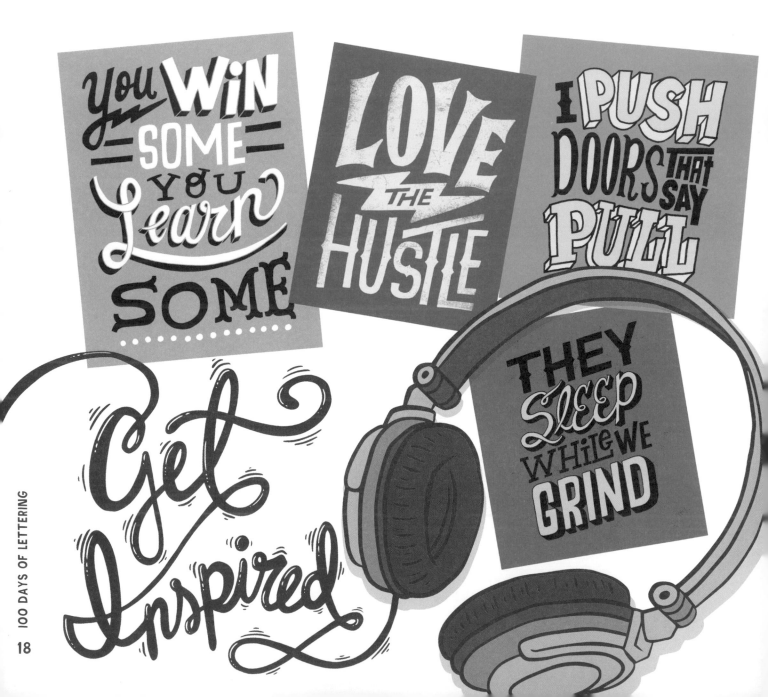

# Capture your thoughts on an
# INSPIRATION LIST

Do you have a favorite lyric from a song you like? How about a funny line from a movie you just watched? Get used to training your mind to recognize these inspirational thoughts. Think of some musical lyrics, movie quotes, and motivation phrases and jot them down on the list below!

1. _____

_____

2. _____

_____

3. _____

_____

4. _____

_____

5. _____

_____

 **INSPIRATION CAN STRIKE AT ANY TIME! CARRY A SMALL NOTEBOOK OR START A LIST ON YOUR PHONE TO MAKE SURE YOU CAPTURE THESE THOUGHTS.**

*Process step 2*
# ROUGH SKETCH

Once I have an idea, I start to roughly sketch it out on paper using a pencil. I don't worry about mistakes or perfecting a finished piece. My focus is to keep my lettering very loose and to start planning out how large or small each word will be and how they will interact with one another. It is important to use simple wireframe letterforms and refrain from adding too much detail this early in the process.

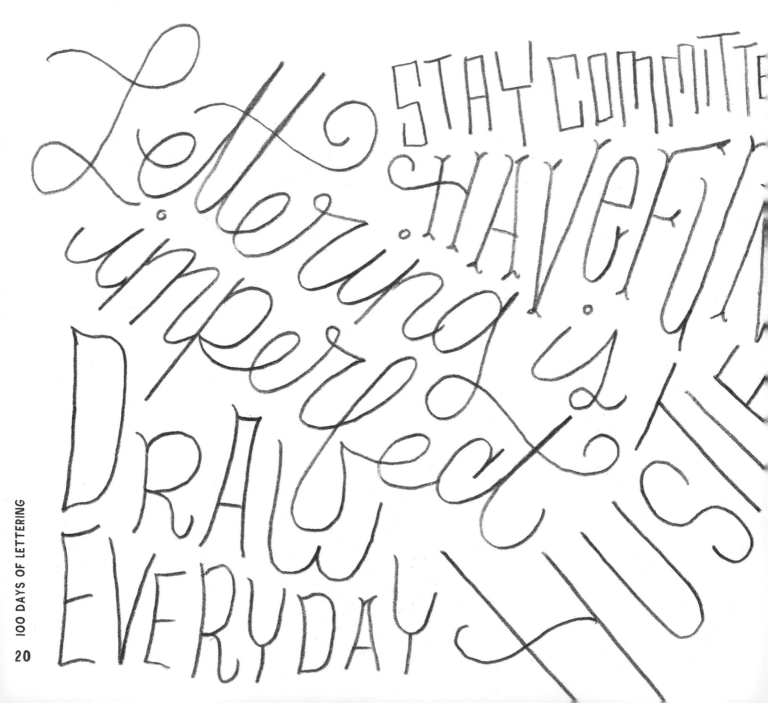

## *Experiment and plan with your own*
# WIREFRAME LETTERING

Using an idea from the list you created yesterday, start to lightly sketch the words in a wireframe styled lettering. Making mistakes is important at this stage, as it helps you learn what works and what does not. Use the space below to roughly sketch and plan out your lettering.

Once the rough sketch composition is in a good place I start to refine my lettering. I sketch directly over my rough sketch or use a sheet of tracing paper to draw each letterform. A mixture of thick and thin strokes creates variation as I layer in detail. I always focus on drawing the letters as opposed to writing them. This step really starts to bring my hand-lettering to life and is the most time consuming.

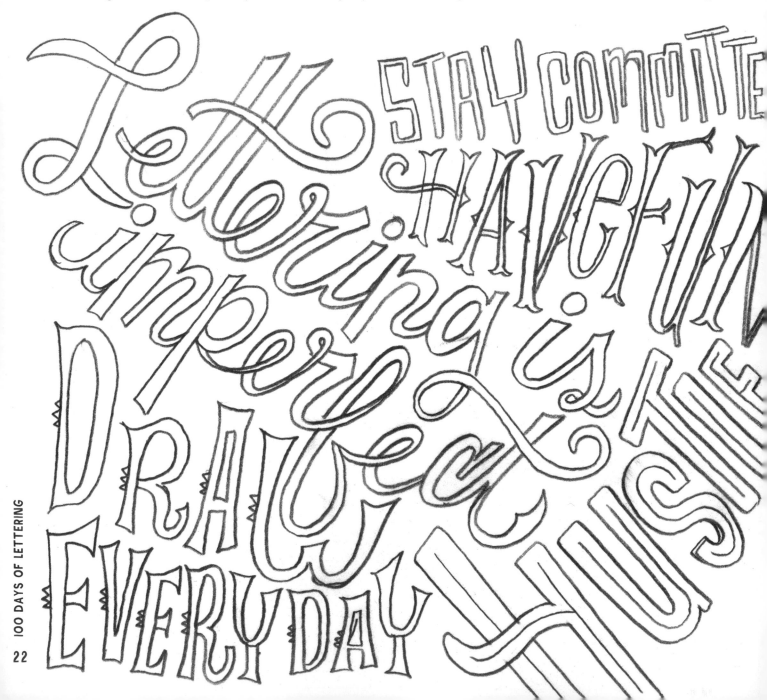

# *Gradually refine your lettering to*
# BRING IT TO LIFE

Taking inspiration from the rough sketches you practiced yesterday, try doing a rough sketch below in light pencil. Once you have the rough sketch in place, start to refine the lettering by tracing your own wireframe sketch. Gradually layer in the lettering detail in stages until you are happy with it.

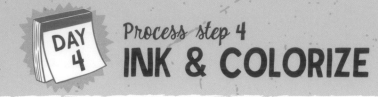

Now that I have committed to a refined sketch, I move to the ink and colorization step. I like to use tracing paper and a fine-tipped black pen or colored markers to trace my sketch, but you can also ink directly over your sketch and then erase the pencil once the ink has dried. This is also a great time to add some additional details to the letterforms.

## Use colored pencils, pens, and markers to
# BRING IT ALL TOGETHER

Start with a rough sketch and gradually refine it. Once you are happy with the refined sketch use a marker or fine-tipped black pen to trace your sketch. Take your time and use a steady hand during this final phase. Once the ink has dried, use an eraser to remove the sketched lettering. If you're looking to refine your artwork even more, try scanning it onto the computer at a high resolution.

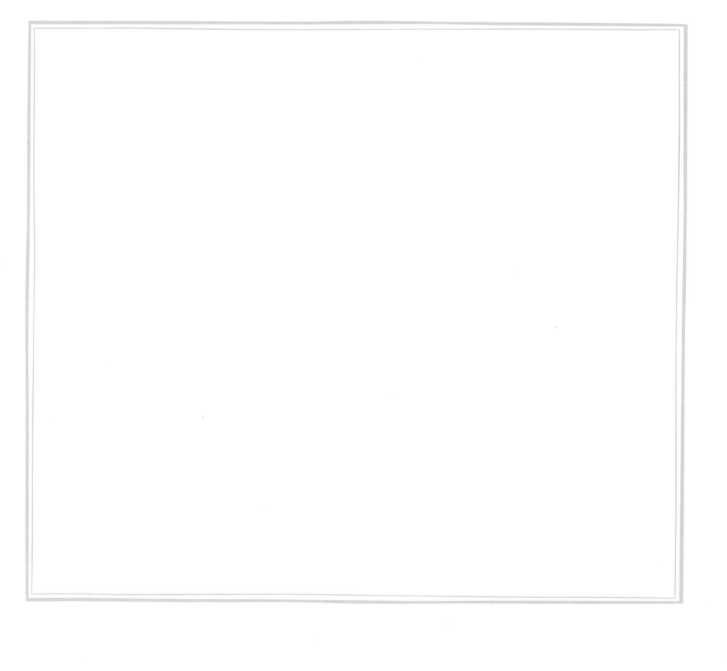

# ESTABLISH A GRID

*Learn how to*

**DAY 5**

A good way to prepare to hand-letter a phrase is to use a grid. A traditional grid is usually square or rectangular and serves as a boundary for your art. This is the first step in planning your composition. Take a look at the hand-lettering below and take notice of the grid that was used to create them. Think about where each word will land in your grid then try lettering into the grids below for practice.

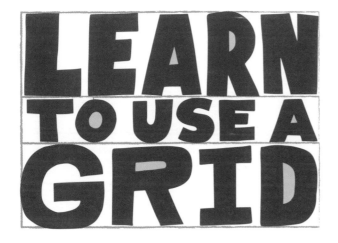

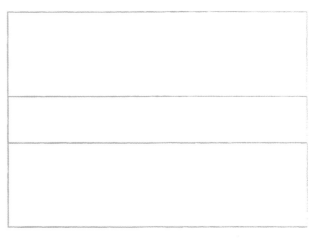

 **TIP** THINK ABOUT HOW MANY WORDS YOU PLAN ON LETTERING AND CREATE A BOX FOR EACH ONE.

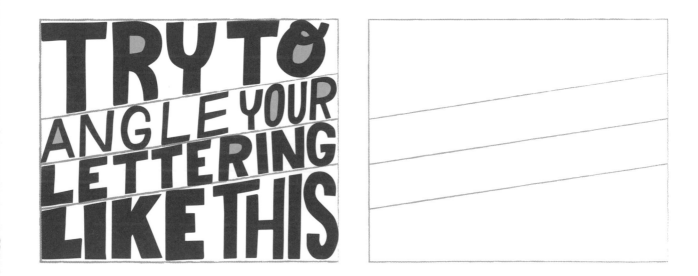

# DAY 6

## *Okay, now* BREAK THE GRID

Traditional grids are very helpful but they are not mandatory. Sometimes, breaking out of a traditional grid can create a less rigid and more organic solution for your lettering. Try lettering into the blank grids below for practice. Fill each shape with words to keep your composition balanced.

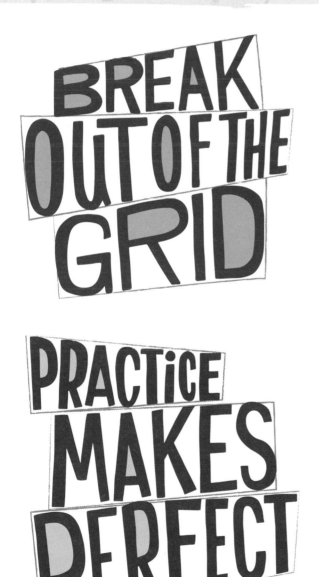

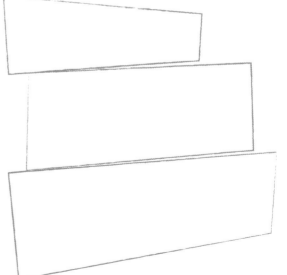

*Practice page*
# CREATE YOUR OWN GRIDS

Think of a few different phrases of varying lengths and create a grid for each of them. As you plan your grids, keep in mind that a grid for a three-word phrase will differ from a grid for a ten-word phrase. Try creating a mixture of traditional and non-traditional grids for different effects.

**TIP** TRY ARCHING OR ANGLING YOUR GRID TO GIVE YOUR LETTERING COMPOSITION A DIFFERENT FEEL.

*Step-by-step*
# SIMPLE LETTERING

So far we've covered workflow process and grids. Now it's time to start putting those processes to work. Let's start with a simple phrase. Remember that hand-lettering is an imperfect discipline.

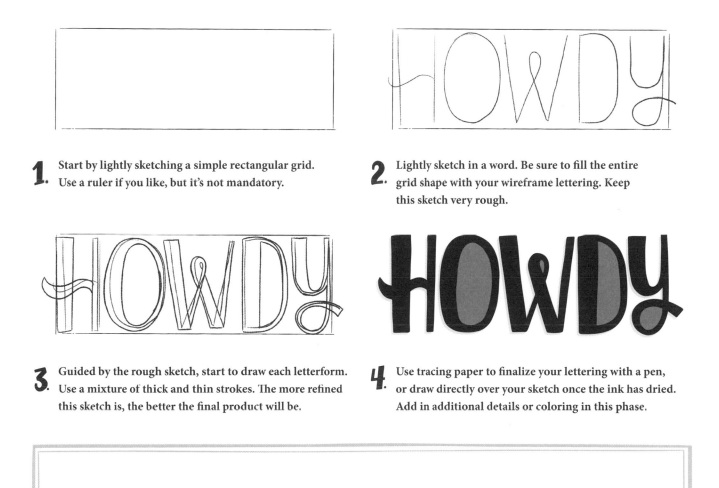

**1.** Start by lightly sketching a simple rectangular grid. Use a ruler if you like, but it's not mandatory.

**2.** Lightly sketch in a word. Be sure to fill the entire grid shape with your wireframe lettering. Keep this sketch very rough.

**3.** Guided by the rough sketch, start to draw each letterform. Use a mixture of thick and thin strokes. The more refined this sketch is, the better the final product will be.

**4.** Use tracing paper to finalize your lettering with a pen, or draw directly over your sketch once the ink has dried. Add in additional details or coloring in this phase.

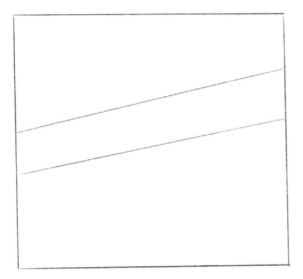

**1.** Start by lightly sketching a simple square grid. Add in a couple of angled lines inside to guide your lettering.

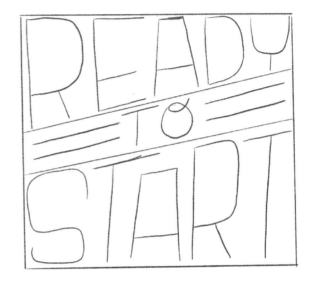

**2.** Lightly sketch in your letters. Follow the angles of your grid to fill the entire shape. Keep this sketch very rough.

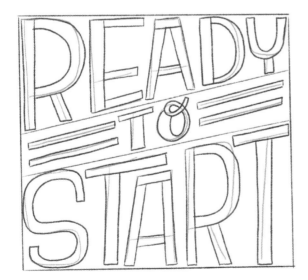

**3.** Using the rough sketch as a guide, draw in each letterform. Sketch in the various pieces that form each letter. The more refined this sketch is, the better the final product will be.

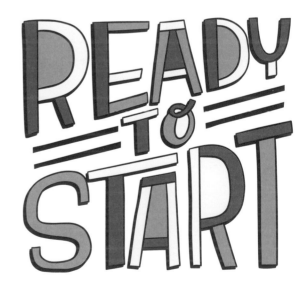

**4.** Use tracing paper to finalize your lettering with a pen, or draw directly over your sketch once the ink has dried. Add in additional details or coloring in this phase.

**TIP** FILL IN THE COUNTERSPACES OF YOUR HAND-LETTERING TO ADD A NICE TOUCH.

# DAY 10

## *Make it a point to*
## DIGITIZE YOUR ART

Learning how to scan your artwork is a necessary skill in order to bring your hand-lettering to the next level. I like to scan in my ink drawings and further refine and colorize my lettering on the computer using digital design programs. It is much easier to play around with various color compositions on a computer than it is to redo your artwork in different colored variations. Aside from the obvious efficiency benefits, scanning your letter drawings is also a great way to archive your work.

 **SCAN YOUR ART AT THE HIGHEST RESOLUTION POSSIBLE TO ASSURE THE BEST QUALITY.**

# Days 11–20
# SANS SERIF & SERIF

The two largest classifications of typefaces are sans serif and serif. Typically, most lettering styles are derived from one of these two categories. The next ten days will place an emphasis on establishing a solid foundation of both the sans serif and serif alphabets. Once you have a firm grasp on these two styles you can really start to branch out with your hand-lettering.

# Learn about
# SANS SERIF & SERIF

Today we are going to focus on learning to discern the small differences between sans serif and serif alphabets. Once you have a firm grasp of the difference between these two styles, try to challenge yourself to recognize their use in your everyday life by looking in books, on mobile devices, at street signs, and show posters. You'll discover sans serif and serif letters are everywhere.

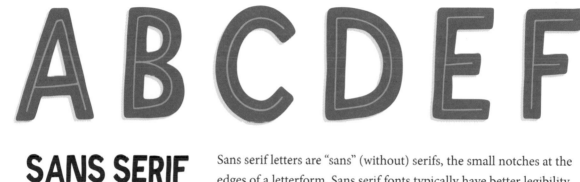

## SANS SERIF

Sans serif letters are "sans" (without) serifs, the small notches at the edges of a letterform. Sans serif fonts typically have better legibility on screen due to their cleaner letterforms.

**Popular Sans Serif Fonts:** Helvetica, Avant Garde, Arial, Geneva, Franklin Gothic, and Futura.

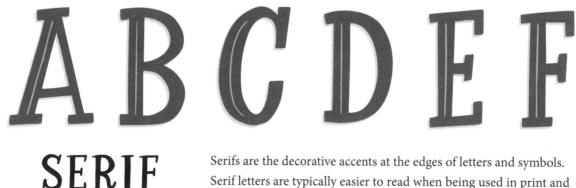

## SERIF

Serifs are the decorative accents at the edges of letters and symbols. Serif letters are typically easier to read when being used in print and smaller sizes like bodies of copy as they guide the eye in a horizontal flow from word-to-word.

**Popular Serif Fonts:** Times Roman, Courier, Bodoni, New Century Schoolbook, and Palatino.

DAY 12

*Sans serif*
# ALPHABET PRACTICE

Let's begin with a nice basic sans serif alphabet. Start by lightly sketching in the simple lines of the letterforms and then gradually layer in and thicken each letter until you're happy with the finished result. Since we're doing an entire alphabet, make each letterform similar in thickness and size.

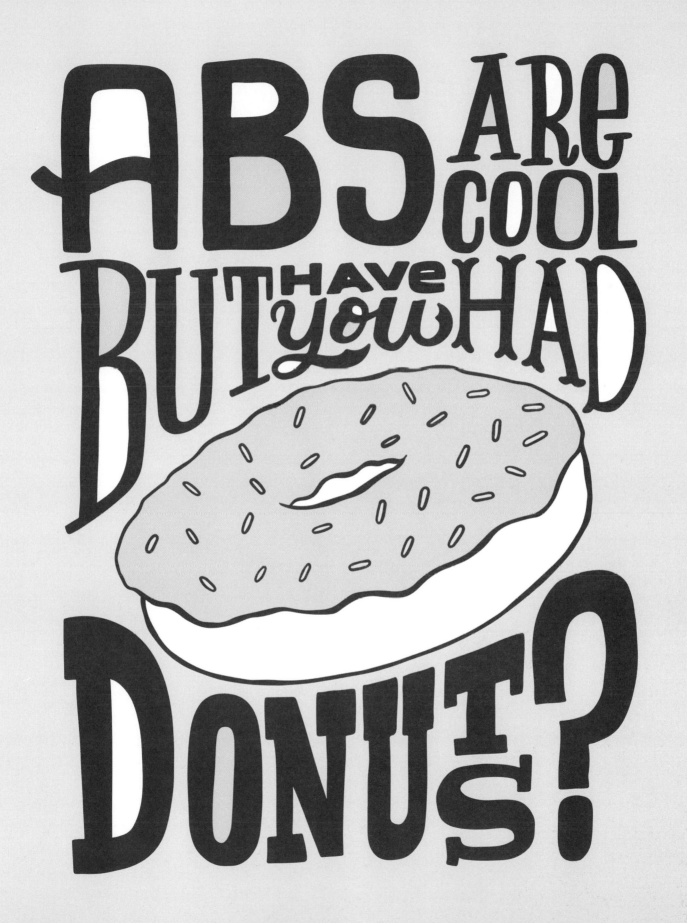

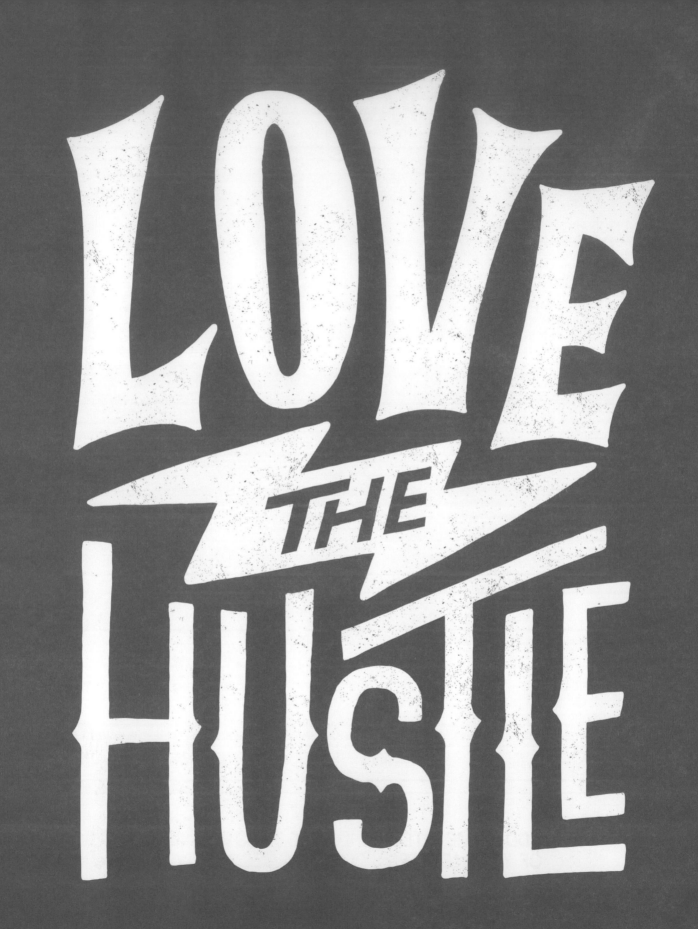

There are many different ways to draw sans serif letters. Challenge yourself to see how many different stylings you can come up with. Use a mixture of thick and thin strokes with some of the letters, and try others that are wide or tall. Remember to start with a rough sketch and layer in the letter styling.

**TIP** ADD SOME INTEREST TO THE TAILS AND CROSSBARS OF YOUR LETTERS BY USING A DECORATIVE SWASH.

**1.** Start by lightly sketching a simple square grid. Add in a couple of angled lines inside it to guide your lettering.

**2.** Lightly sketch in your letters. Follow the angling of your grid to fill the entire shape. Keep this sketch very rough.

**3.** Using the rough sketch as a guide, draw in each letterform. Sketch in the various pieces that form each letter. The more refined this sketch is, the better the final piece will be.

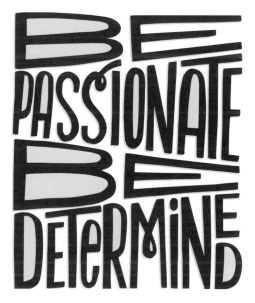

**4.** Use tracing paper to finish your lettering with a pen, or draw directly over your sketch once the ink has dried. Add in additional details or coloring in this phase.

TIP FEEL FREE TO USE A MIX OF LOWER AND UPPER CASE LETTERS
TO CREATE A SENSE OF VARIATION AND MOVEMENT.

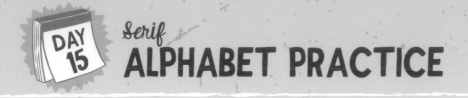

Now that you have done a sans serif alphabet, let's try a serif alphabet. Start by lightly sketching in the simple lines of the letterforms and gradually layer in and thicken each letter until you're happy—and don't forget to add the serifs! Make each letterform similar in thickness and size.

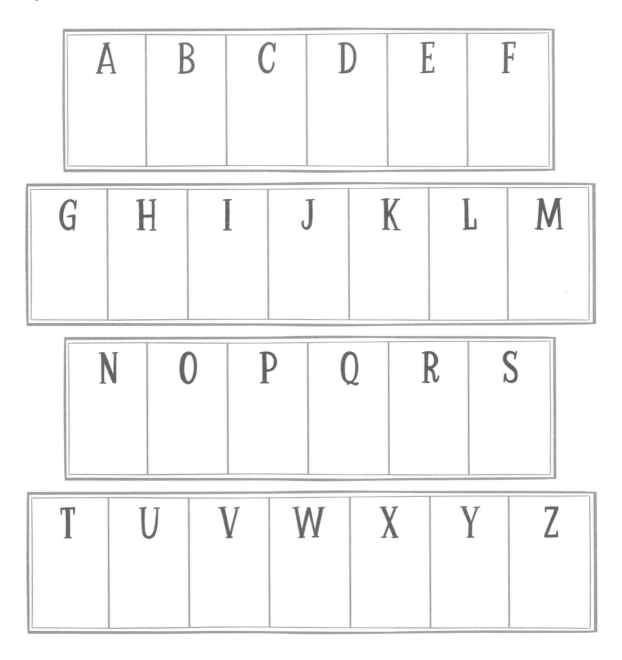

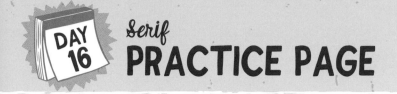

As is the case with sans serif letterforms, there are also many different ways to draw a serif letter. See how many different stylings you can come up with. Try using a mixture of sharp and rounded serifs with some of your letters. Remember to start with a rough sketch then layer in the letter styling.

**TIP** START BY DRAWING SERIF LETTERFORMS, THEN ADD SERIFS AT THE ENDS TO MAKE THEM SANS SERIF LETTERS!

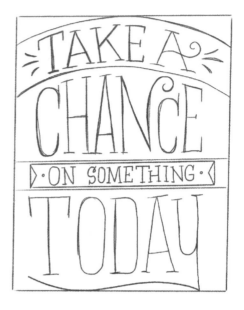

**1.** Start by lightly sketching a simple square grid. Add a couple of angled lines inside it to guide your lettering.

**2.** Lightly sketch in your letters. Follow the angle of your grid to fill the entire shape. Keep this sketch very rough.

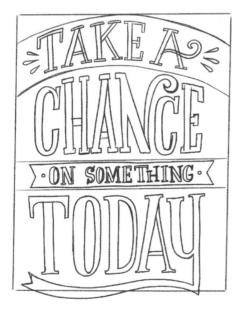

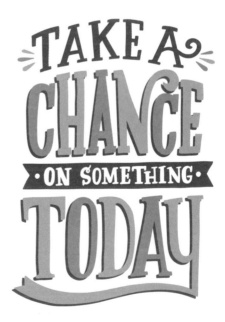

**3.** Using the rough sketch as a guide, draw in each letterform. Sketch in the various pieces that form each letter. The more refined this sketch is, the better the final product will be.

**4.** Use tracing paper to finalize your lettering with a pen, or draw directly over your sketch once the ink has dried. Add in additional details or coloring in this phase.

 **TRY USING SEVERAL DIFFERENT SHADES OF A COLOR IN YOUR LETTERING TO CREATE A NICE EFFECT.**

# Create your own
# CUSTOM ALPHABET

You've conquered the sans serif and serif alphabets, so now it's time to come up with your own custom alphabet. It can be sans serif or serif, thick or thin, tall or short, with hard edges or round—the point is to have fun with it! And don't forget to give your alphabet a name once you've finished.

## GIVE YOUR ALPHABET A NAME: _____

*Hand-letter your*
# FAVORITE QUOTE

Do you have a favorite quote or music lyric? Try using the alphabet you created on Day 18 as a lettering style reference to turn your quote into a hand-lettering masterpiece. Use the process we've been practicing to create a grid and gradually layer in detail to bring your lettering artwork to life.

 **TIP** **EMPHASIZE MORE IMPORTANT WORDS BY MAKING THEM LARGER AND MORE PROMINENT.**

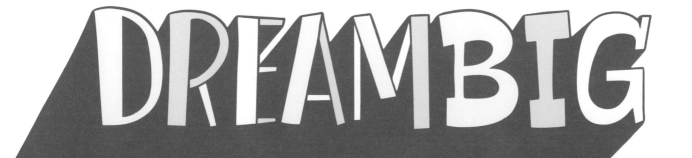

SANS SERIF & SERIF

*Sans serif and serif*
# SKETCH-PLORATION

Now that you have a solid handle on the sans serif and serif letterforms you can use Day 20 to further practice these styles. Try hand-lettering your name, or some musical lyrics. There are no rules!

GO CRAZY

SKETCH IT OUT

MAKE MISTAKES

EXPLORE

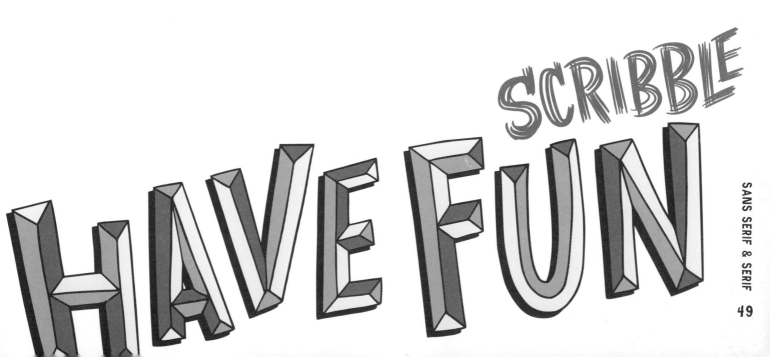

SCRIBBLE

HAVE FUN

# Days 21-30
# CURSIVE SCRIPT

Writing in cursive is a good skill to have if you'd like to complement a more standard lettering style with something that is a bit more interesting. This section is all about having fun with your cursive lettering and will cover a range of topics, from alphabets to flourishes. Let's get started on one of my favorite styles!

# Learn about
# CURSIVE SCRIPT

We all learned how to write in cursive in grade school and then promptly forgot about it. Well, it's time to reacquaint yourself with it! Cursive is a form of script that is characterized by letters that are joined together in a single flowing manner. Although cursive script is traditionally joined together, it can also be executed in a more casual fashion with a combination of joined and unjoined lettering. Cursive script has the ability to truly take on the unique and personalized style of the artist creating it.

*Cursive alphabet practice*
# UPPER CASE

Let's begin with an upper case script alphabet. Start by writing each letterform in one fluid movement. Gradually layer in a combination of thick and thin stroke weights. Since we're doing an entire alphabet, it is important that each letterform consistently follows the same angle and stroke thickness.

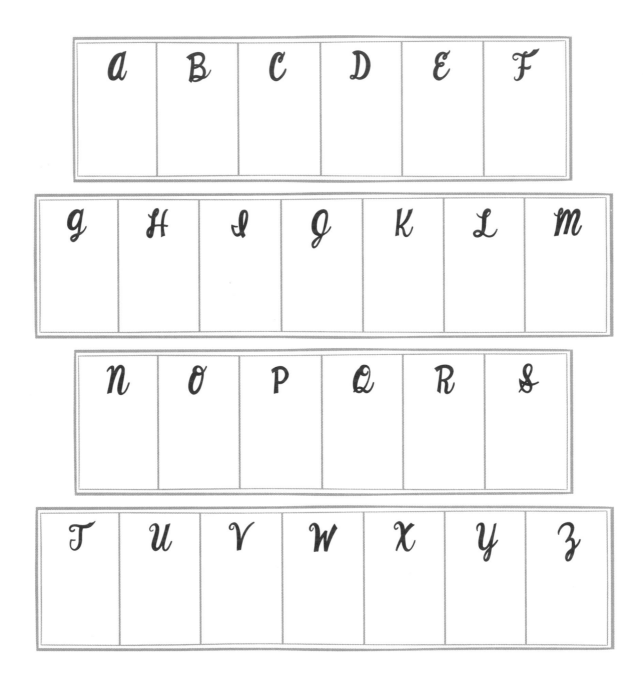

# DAY 23
## *Cursive alphabet practice*
## LOWER CASE

Now that we have covered the upper case alphabet it's time to learn its lower case counterpart. Start by writing each letterform in one fluid movement. Gradually layer in a combination of thick and thin stroke weights. Make sure each letterform follows the same angle and stroke thickness for continuity.

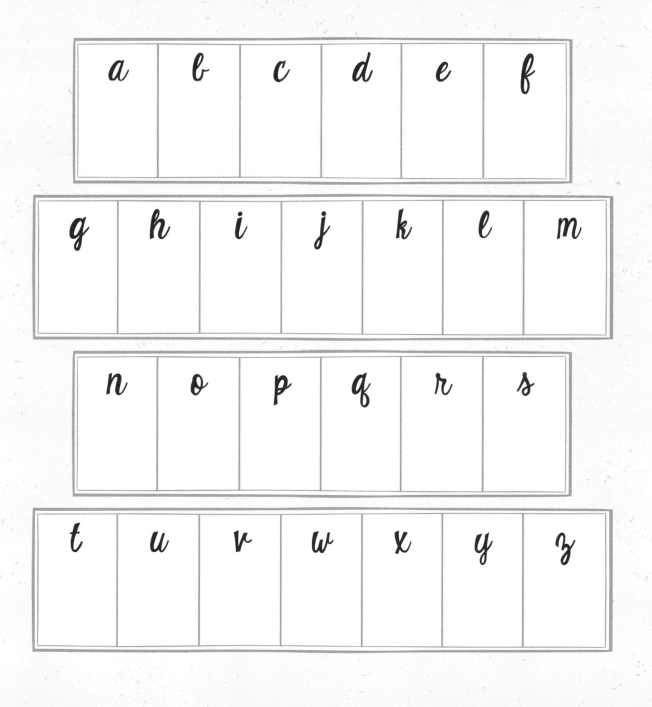

Adding flourishes to your cursive lettering provides a unique opportunity to really push it to the next level. Try drawing some of my favorite letterforms (below) with a focus on coming up with different ways to handle the flourishes on each. Give your flourishes plenty of room to breathe.

**TIP** AVOID ABRUPT ANGLES AND SHARP CORNERS WHEN ADDING FLOURISHES TO YOUR LETTERING.

*Learn to create*
# BOUNCE LETTERING

Bouncing your lettering off the baseline is a way to distinguish it from traditional calligraphy and make it more visually interesting. In order to get the bounce effect some rules need to be broken—so forget about keeping a consistent baseline as a guide for your lettering. Remember, there are no rules to breaking the rules. Practice bouncing your lettering (as below) to give it a fun and unique effect.

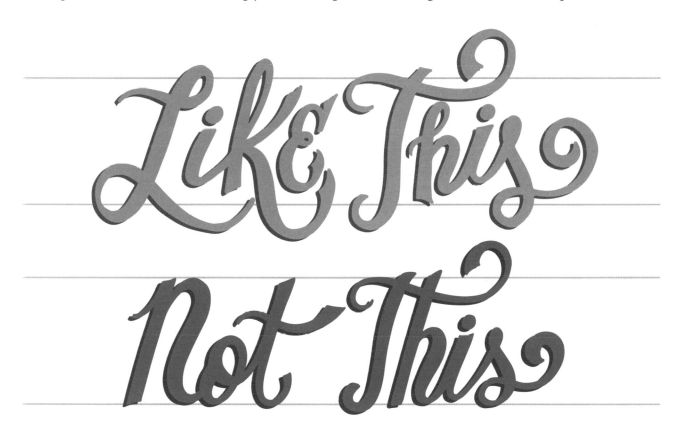

**DAY 26**

*Simple step-by-step*
# CURSIVE SCRIPT

Now that we've gone over some alphabets and ideas, it's time for the fun part—creating the lettering artwork! Take your time and follow the steps below to devise a simple piece of letter art.

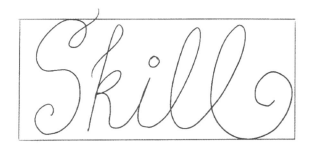

**1.** Start by lightly sketching a simple rectangular grid. Use a ruler if you like, but it's not mandatory.

**2.** Lightly write in a simple word in cursive. Fill the entire grid shape and keep the flow of your lettering very natural.

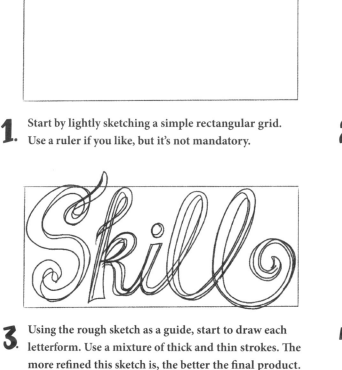

**3.** Using the rough sketch as a guide, start to draw each letterform. Use a mixture of thick and thin strokes. The more refined this sketch is, the better the final product.

**4.** Use tracing paper to finalize your lettering with a pen, or ink directly over your sketch. Erase the sketch once the ink has dried. Add in additional details or coloring in this phase.

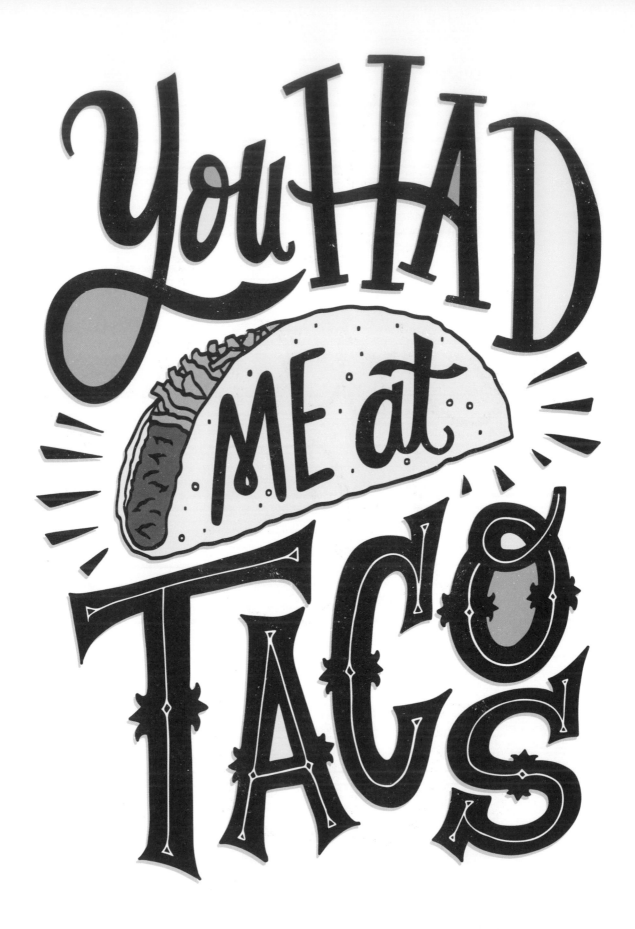

*Cursive script*
# PRACTICE PAGE

Use these shapes to house your cursive hand-lettering. Lightly sketch your letters before you commit to your design to make sure that it will fit into each shape. Use flourishes to help fill any negative space.

 **KEEP YOUR STROKES FLUID AND FREE FLOWING FOR A SMOOTH AND NATURAL CURSIVE FEEL.**

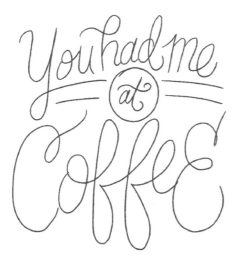

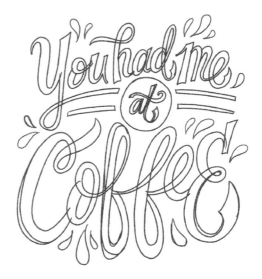

**1.** Now let's break away from the traditional grid and go for a more freeform effect. Use a mixture of large and small lettering to add some variation to your composition.

**2.** Using the rough sketch as a guide, draw in each letterform. Sketch in the various pieces that form each letter. The more refined this sketch is, the better the final product will be.

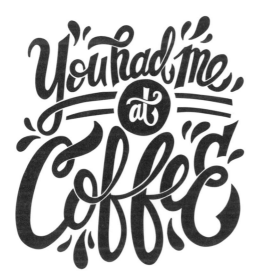

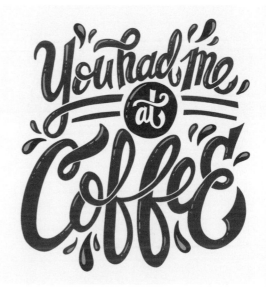

**3.** Use tracing paper to finalize your lettering with a pen, or ink directly over your sketch. Erase the sketch once the ink has dried. Add in additional details or coloring in this phase.

**4.** Let's take the art a step further. Scan it into the computer and colorize it. Add some extra last minute details and a background color to boost it to the next level.

 **USE FLOURISHES TO FILL NEGATIVE SPACE AND PROVIDE BALANCE TO YOUR CURSIVE LETTERING COMPOSITION.**

*Cursive script*
# STYLE CHALLENGE

It's time to expand your cursive lettering repertoire! Today, let's focus on coming up with as many different cursive lettering styles as you can while using the same word. Use the styles that I created as inspiration to help you come up with your own new styles. Ready, set, go!

**TIP** EXPLORING DIFFERENT LETTERING STYLES WILL HELP YOU COME UP WITH YOUR OWN STYLE.

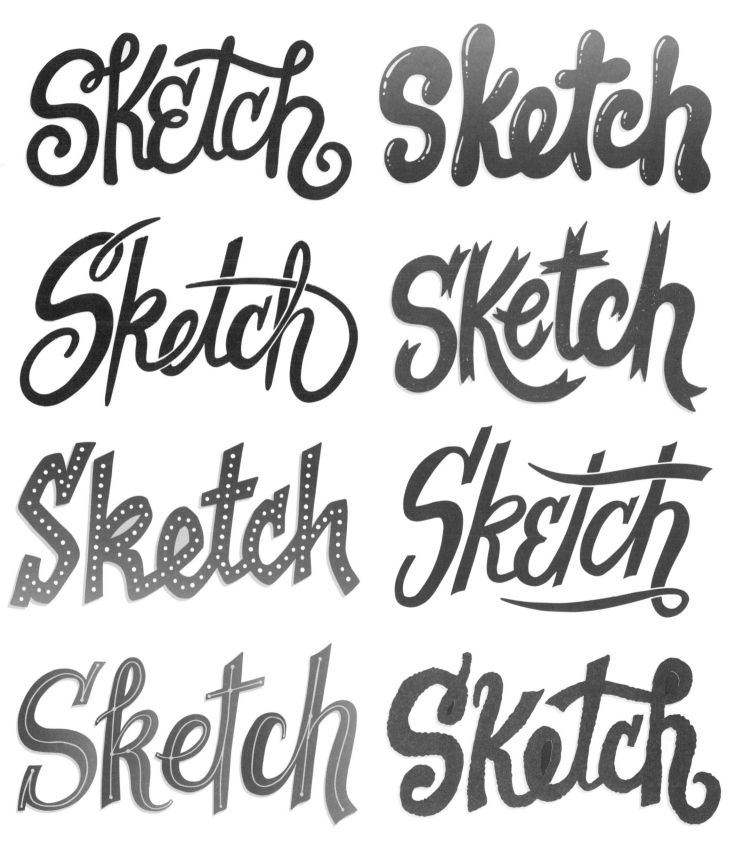

*Cursive script*
# SKETCH-PLORATION

Now that you have a solid handle on cursive script letterforms, you can use this spread to further practice variations of the style. Try hand-lettering your name, or a quote. There are no rules!

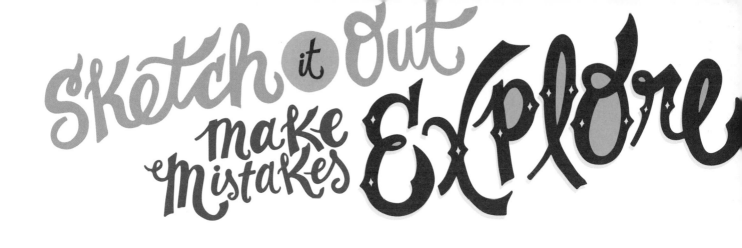

Sketch it Out
make Mistakes
Explore

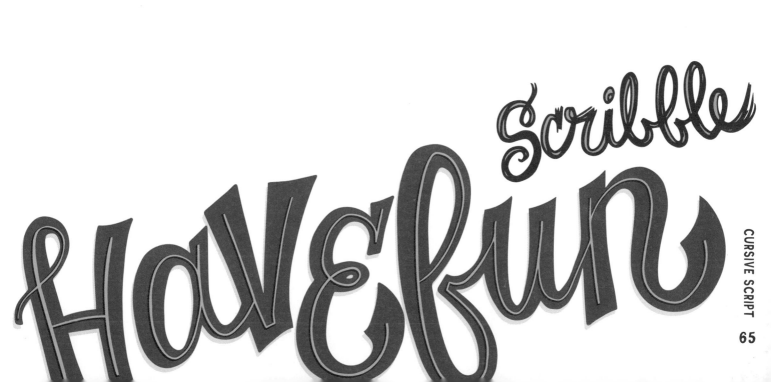

Scribble
Have fun

# Days 31–40
# BRUSH & WESTERN

Brush and western lettering are two very different lettering styles—they're great fun. There are many different ways to draw them both and some of them are covered in this section. Over the next ten days, I will be sharing some helpful tips and step-by-step processes to get you started with drawing your own brush and western-styled lettering.

## How to create
# BRUSH LETTERING

Brush lettering is a beautiful craft that is inspired by sign painting and calligraphy. In order to hand-letter in a brush lettering style, it is important to understand the characteristics of a brush stroke. Most often brush downstrokes are all consistently angled and the crossbars and upstrokes, or thin parts of brush lettering, use lighter pressure. The ends of a brush stroke can be jagged at times, depending on the effect you are going for. It is common for brush strokes to overlap, and hang over other brush strokes. Check out the pictures below to learn how beautiful hand-drawn brush lettering is created.

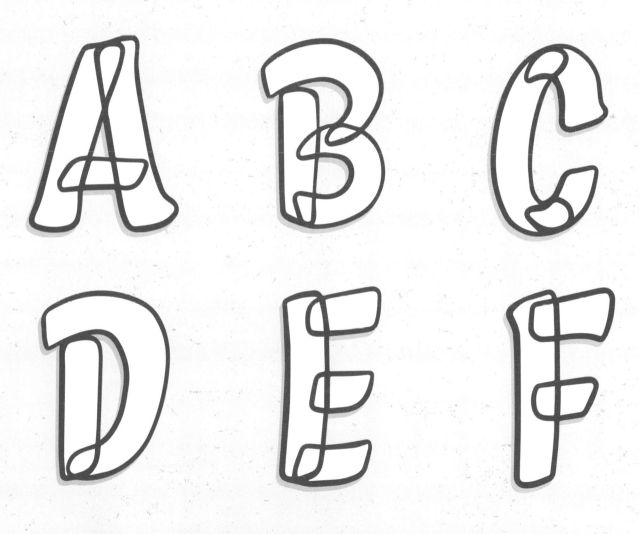

 **LEARN TO BREAK DOWN EACH LETTERFORM INTO A SERIES OF OVERLAPPING SWASHY SHAPES.**

## *Brush lettering*
# ALPHABET

Let's begin with a strongly-angled brush lettering alphabet. Pay attention to the angle of the lettering and enjoy the loose nature of its appearance. Start by writing each letterform in quick and fluid movements—let some of the strokes overlap others to provide a more dynamic appearance.

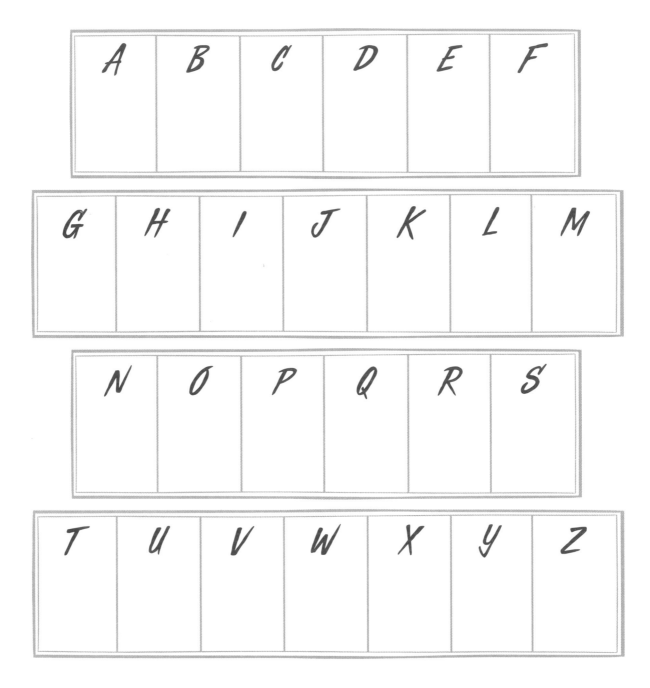

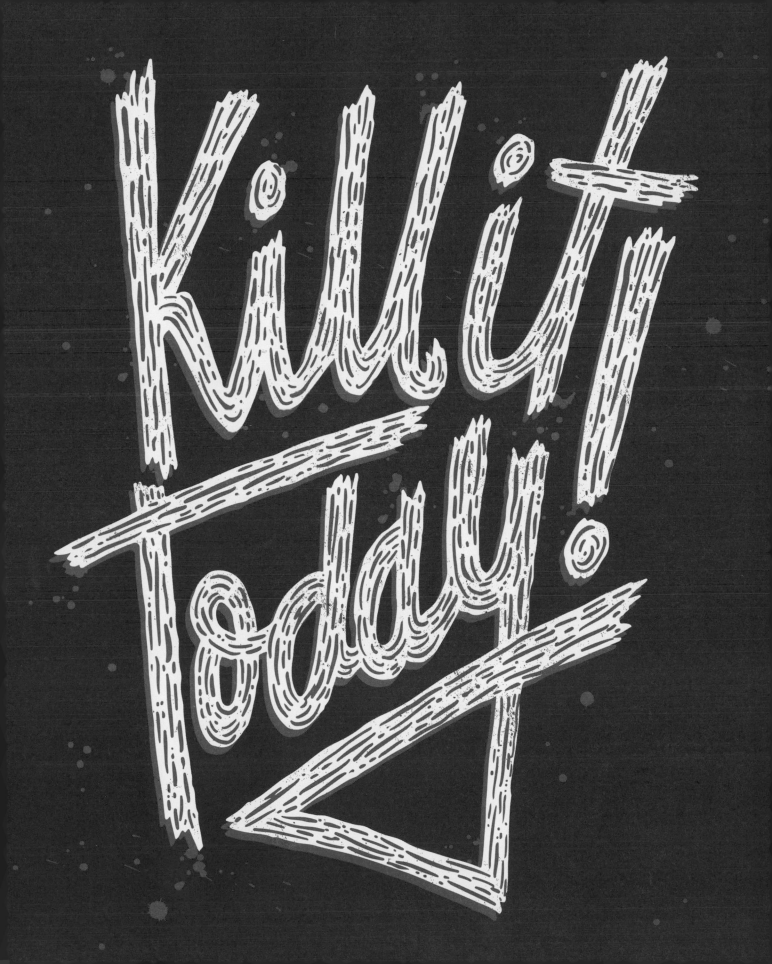

*Simple step-by-step*
# BRUSH LETTERING

Lightly sketch your lettering before you commit to it. Focus on breaking down each letterform into a series of shapes, such as in step three below. Keep the lettering loose. You've got this!

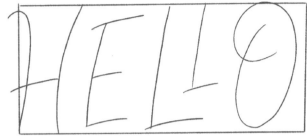

**1.** Start by lightly sketching a simple rectangular grid. Use a ruler if you like, but it's not mandatory.

**2.** Lightly write in a simple word. Fill the entire grid shape and keep the flow of your lettering very natural.

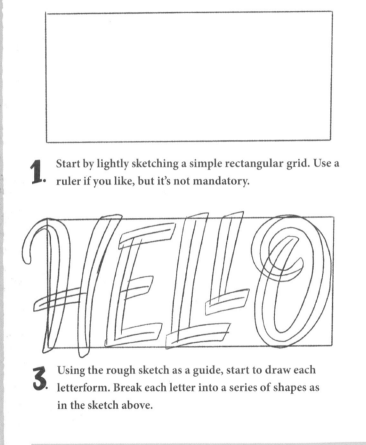

**3.** Using the rough sketch as a guide, start to draw each letterform. Break each letter into a series of shapes as in the sketch above.

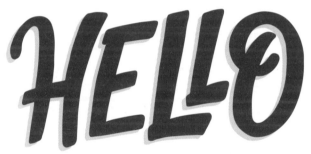

**4.** Use tracing paper to finalize your lettering with a pen, or ink directly over your sketch. Erase the sketch once the ink has dried. Add in additional details or coloring in this phase.

# DAY 34
## Brush lettering
## ANGLED LETTERING

Adding a slight angle or slant to your lettering can dramatically change its appearance. Use the guidelines below to practice angling your brush lettering. Keep consistent vertical angles in your linework and don't be afraid to let your ascenders and descenders break out of the guidelines. This effect can be added to any hand-lettering style, not just brush lettering.

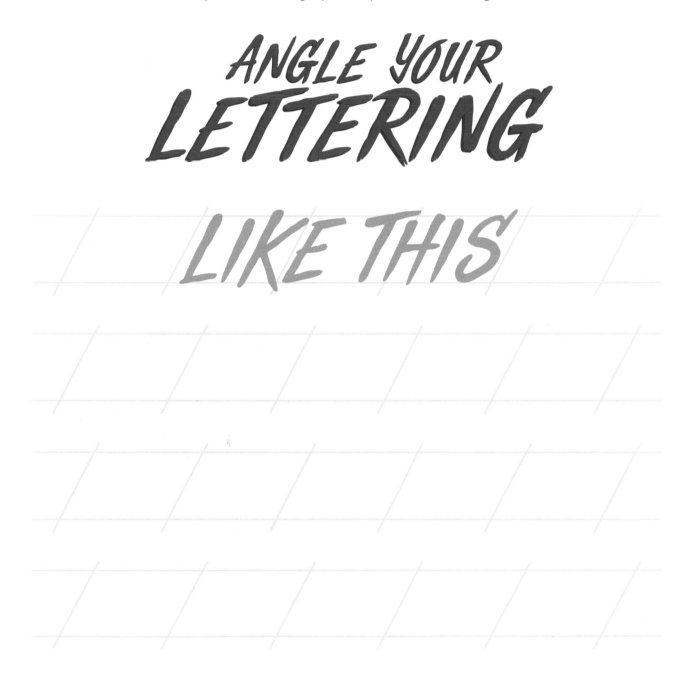

*Step-by-step*
# BRUSH LETTERING
## WITH KYLE LETENDRE

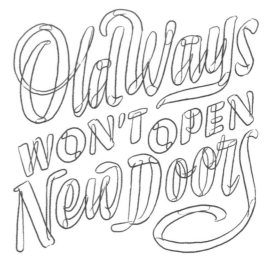

**1.** Start with some small thumbnail sketches of the phrase you want to letter, so you can experiment with different layouts and compositions. Once one looks good, sketch it out loosely in a thin line. This will act as the skeleton.

**2.** Next I usually draw the shapes of brush strokes around the skeleton lines. I like to draw the outlines of strokes even when not using a real brush to make sure we keep some of the brush character.

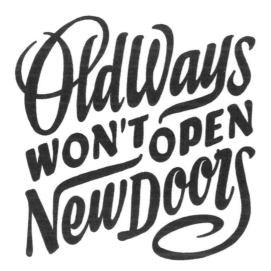

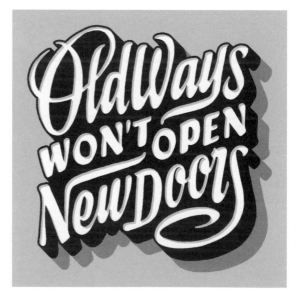

**3.** Keep refining the overall shape. Maybe a swashy "Y" can get a little crazier; maybe the top of an "H" has room to swirl into a nice curl! Once it looks good, I fill the shapes in.

**4.** Now you're ready to scan this bad boy in. Play around with different effects and see what works for you. I'm always partial to a good dimensional shadow.

**TIP** MISTAKES ARE EVIDENCE OF HUMANS MAKING THE WORK, SO DON'T BE AFRAID TO MAKE THOSE WORK IN YOUR FAVOR. SPILLED INK? NOW IT'S EXPRESSIVE! SMUDGY ERASER? NOW IT'S SMOKY!!

# DAY 36

## *Practice page*
# WESTERN STYLING

All lettering styles start from a simple sans serif letterform and western styling is no different. Work on each grayed out letterform below—have fun with your serifs, as they can really give your letterforms a lot of character. Use the styles I have started below as inspiration—and keep them western-themed!

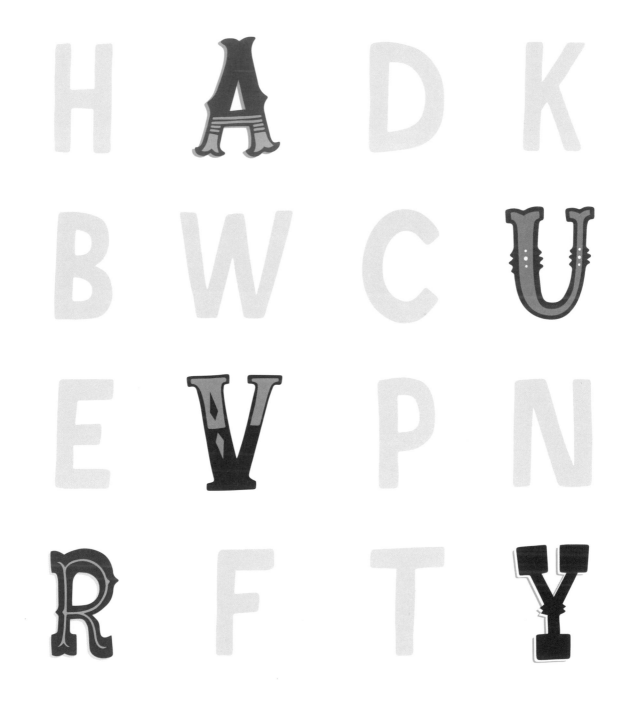

*Simple step-by-step*
# WESTERN LETTERING

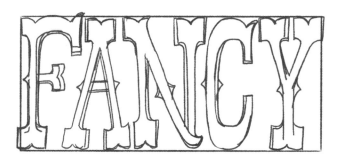

**1.** Start by lightly sketching a simple rectangular grid. Use a ruler if you like, but you don't have to. Keep your lettering very loose and simple.

**2.** Start to layer in western styling to each letterform. I worked my way from left to right, applying lots of rough styling, as you can see by the linework above.

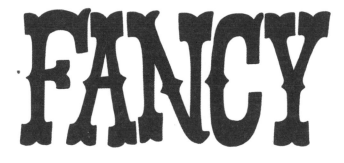

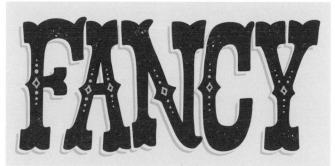

**3.** Use tracing paper to finalize your lettering with a pen, or ink directly over your sketch. Erase all of the underlying sketch once the ink has dried.

**4.** Let's take the art a step further. Scan it into the computer and colorize it. Add some additional last minute fancy details and a background color to make it more dynamic!

**1.** Create a square grid with some angled guidelines inside to help serve as boundaries for your hand-lettering. I always have an idea of where each word will go at this stage.

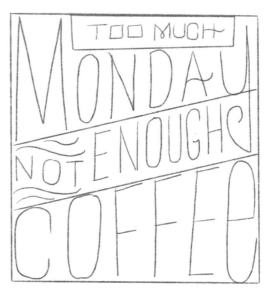

**2.** Draw in plain skeleton letterforms and concentrate on filling each guideline box. Use a mixture of large and small lettering to make your artwork more dynamic.

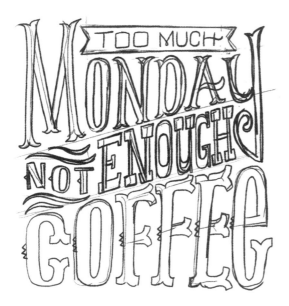

**3.** Start to layer in your styling to each letterform. I used several different Western lettering styles by applying many different layers of sketching, as you can see above.

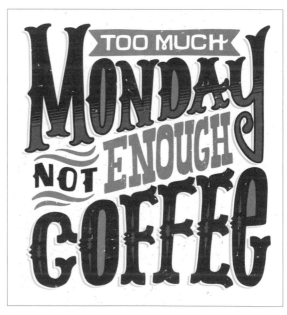

**4.** Once you've inked the artwork, scan it into the computer and colorize it. Add some additional last minute details and a background color to make the composition stand out.

TIP WHEN YOU HAVE TWO OF THE SAME LETTERS NEXT TO ONE ANOTHER, TRY DRAWING ONE IN UPPER CASE AND THE OTHER IN LOWER CASE TO HELP SEPARATE THEM VISUALLY.

*Brush & western*
# STYLE CHALLENGE

It's time to expand your brush and western lettering repertoire! Today, let's focus on coming up with as many different styles as you can while using the same word. This is a great exercise to help you evolve your own unique style. Sketch small and fast to create a wide variety of options.

**TIP** EXPLORING DIFFERENT LETTERING STYLES WILL HELP YOU COME UP WITH YOUR OWN PERSONAL STYLE.

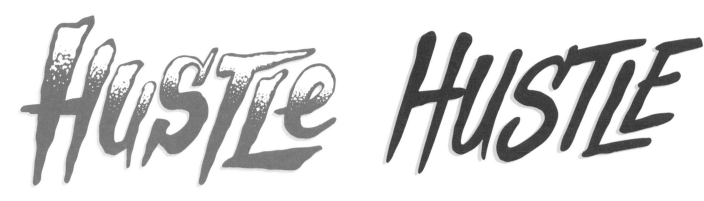

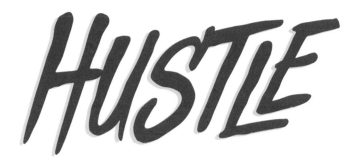

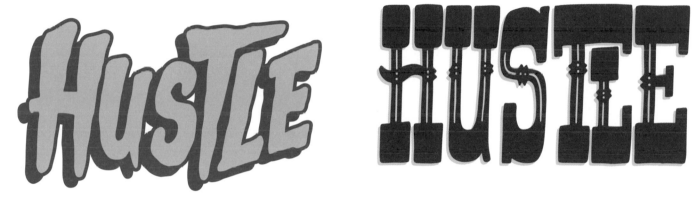

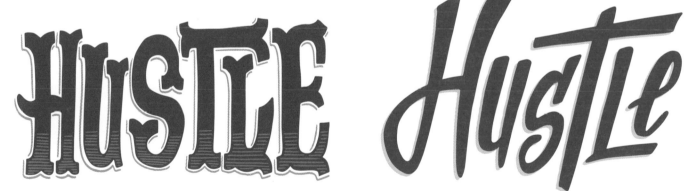

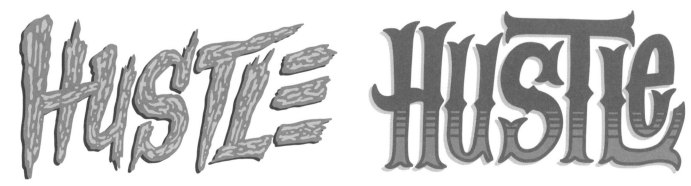

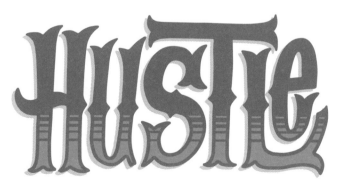

## *Brush & western*
# SKETCH-PLORATION

Now that you have a solid handle on brush and western-styled letterforms, you can use this spread to practice variations of the style. Try hand-lettering a simple motivational quote or a musical lyric.

go crazy

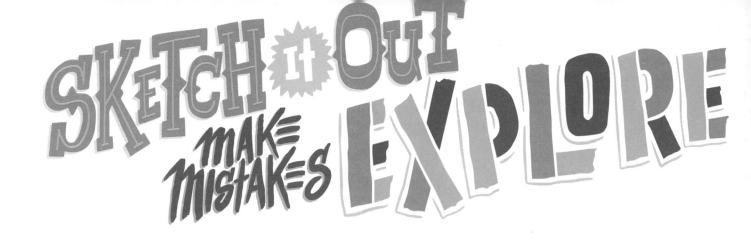

SKETCH IT OUT
MAKE MISTAKES
EXPLORE

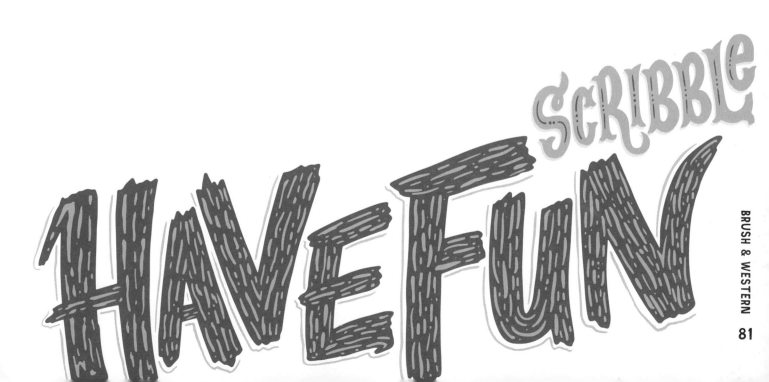

SCRIBBLE
HAVE FUN

# Days 41–50
# DETAIL & DIMENSION

Now that you have a decent grasp of several different lettering styles it's a good time to learn how to take your artwork a step further. This section will help you learn some different ways to add detail and dimension to your lettering compositions.

## DAY 41 · Learn about DETAIL & DIMENSION

Are you looking for a way to make your hand-lettering stand out a bit more? Then look no further. Even adding a simple inline or extra dimension to your lettering will achieve this effect. When choosing what words you'd like to accentuate, it is important to establish a hierarchy. A healthy mix of plain lettering and detailed or dimensional lettering allows your compositions to be more balanced and easier to read. Keep an eye out for lettering with detail and dimension, and find inspiration on internet style sites and in books and magazines. Check out some of the detailing and dimensional styles below.

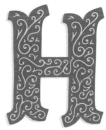
**INNER FILIGREE**

**LINE SHADOW**

**DIMENSION**

**DETAILED DIMENSION**

**INNER STIPPLING**

**INNER DIMENSION**

**DOTTED INLINE**

**INNER MOTIF**

**GLOSSY**

**GRADATED SHADING**

**OUTLINE**

**FILIGREE**

## *How to draw*
# DIMENSIONAL LETTERS

Adding dimension to your lettering can provide a really impactful result. It is a relatively simple effect to do and it can also be applied to any lettering style. Check out the three simple steps below.

### STEP 1

Once you're drawn a letterform, add angled lines to the edges. Each line should share the same angle.

### STEP 2

Connect the angled lines you drew in Step 1, and fill in any letterform counter spaces with dimension.

### STEP 3

Now that you have your dimensional linework finished and in place, it's time to add color to the dimension.

## TRY DRAWING DIFFERENT ANGLES

Changing the angles of your dimensions can achieve different effects. Imagine a viewpoint and think about what angle you'd like to view your letterforms from: the right or left side; from above or below? Practice drawing dimensions in different directions and with different lengths like the examples above.

## Practice drawing
# DIMENSIONAL LETTERS

Yesterday we learned about the process of adding drop shadows. Today, let's practice adding dimension to the various letterforms below. Use different angles and lengths to create different effects.

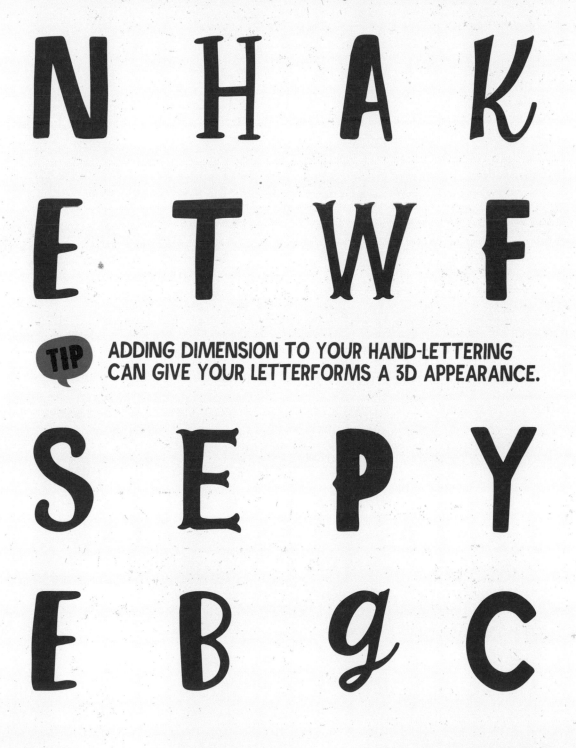

**TIP** ADDING DIMENSION TO YOUR HAND-LETTERING CAN GIVE YOUR LETTERFORMS A 3D APPEARANCE.

# DAY 44

## Simple step-by-step
# DIMENSIONAL WORD

Today let's practice drawing an entire word with dimension. Lightly sketch your lettering before you commit to it. Once you have the style worked out, add in the dimensional effect to each letterform.

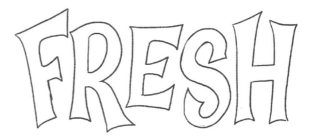

**1.** Start by lightly sketching a simple word. Try bouncing the letters off the baseline to make your composition more fun.

**2.** Using the linework you drew in Step 1, start to gradually layer in each letterform.

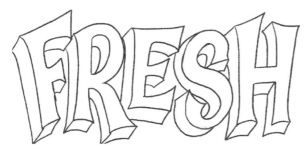

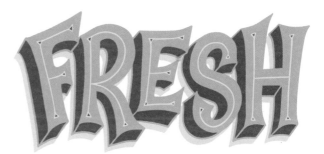

**3.** Decide what angle you'd like your dimensional effect to travel, and work from left to right adding it in.

**4.** Use tracing paper to finalize your lettering with a pen, or ink directly over your sketch. Erase the sketch once the ink has dried. Add in extra details or coloring in this phase.

**1.** Let's break away from the traditional grid and go for a more freeform effect. Use a mixture of large and small lettering to add some variation to your composition.

**2.** Using the rough sketch as a guide, draw in each letterform. Sketch in the various pieces that form each letter. The more refined this sketch is, the better the final product will be.

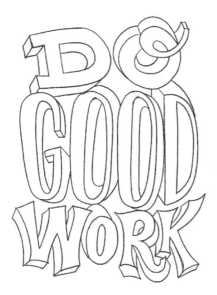

**3.** Add in different dimensional angles to each different letterform to give this hand-lettering composition a fun and playful vibe. The more refined this sketch is the better.

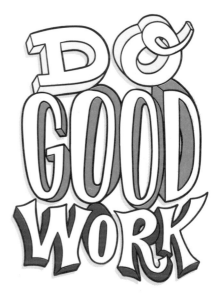

**4.** Use tracing paper to finalize your lettering with a pen, or ink directly over your sketch. Erase the sketch once the ink has dried. Add in extra details or coloring in this phase.

 USE DIFFERENT COLORS FOR EACH WORD TO PROVIDE VARIATION AND MAINTAIN LEGIBILITY.

# *Hand-lettering*
# DETAIL PRACTICE

Whether it's an inline or a series of dots, lettering detail accentuates a letterform. Use some of the detailed letterforms I've done as inspiration, and add detail to the unfinished gray letters below.

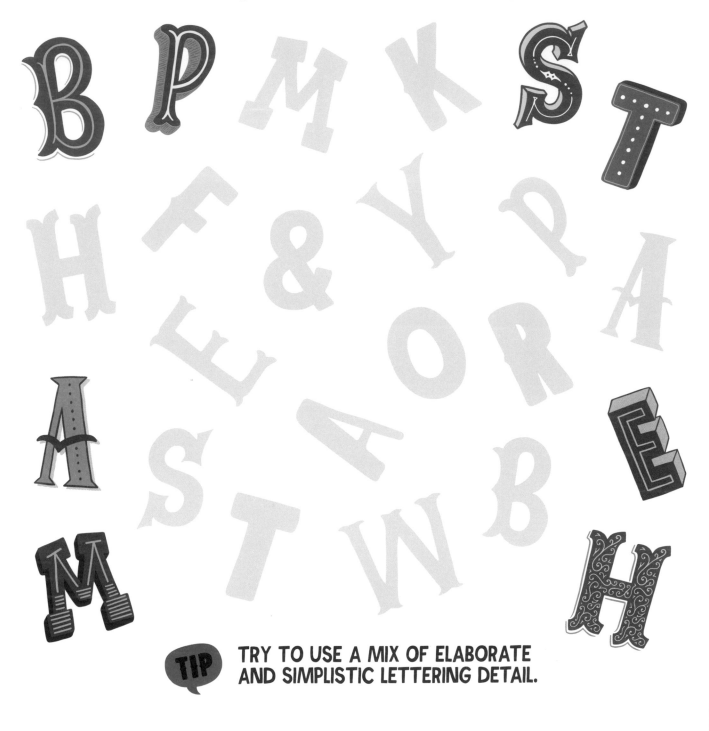

**TIP** TRY TO USE A MIX OF ELABORATE AND SIMPLISTIC LETTERING DETAIL.

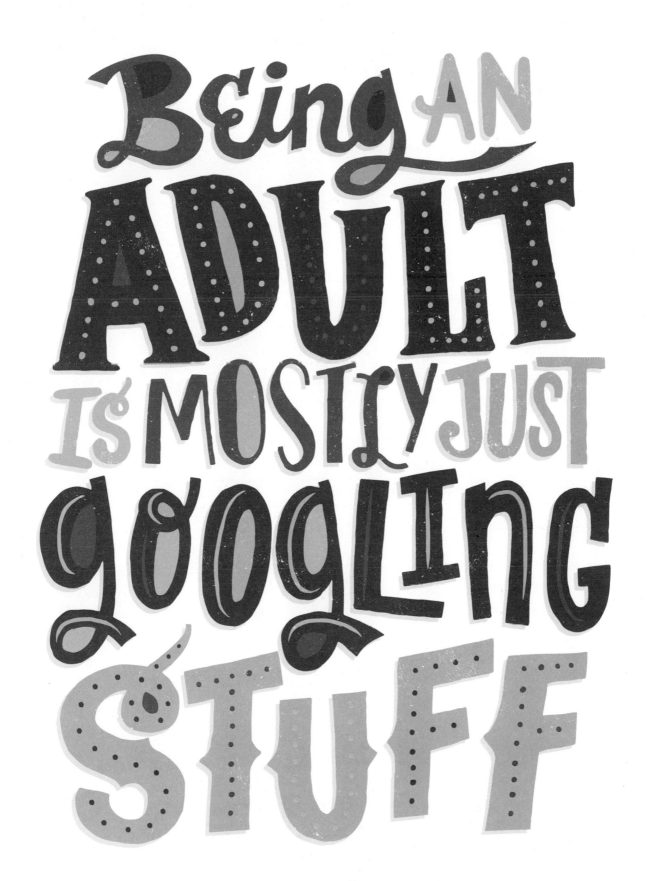

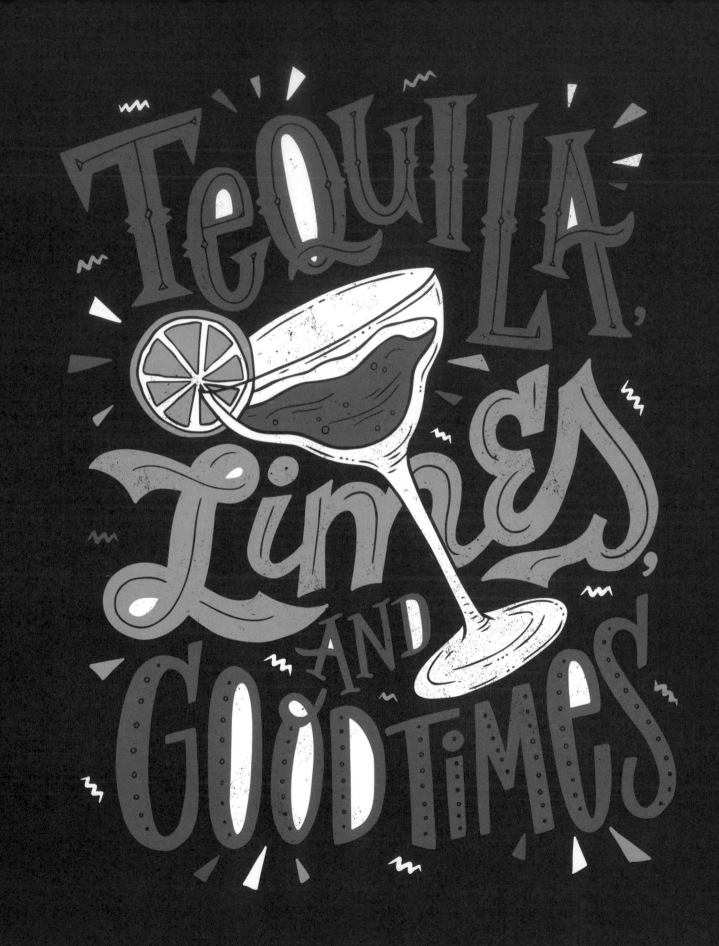

# *Simple step-by-step*
# LETTERING DETAIL

**1.** Start by lightly sketching a simple rectangular grid. Use a ruler if you like, but it's not mandatory.

**2.** Using the rough sketch as a guide, start to draw each letterform. Let's go here with a softly rounded letterform.

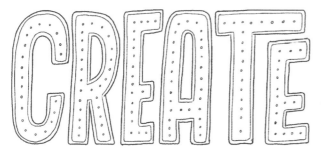

**3.** Layer in an inline and some decorative dot accents. The more refined this sketch is, the easier the final step will be.

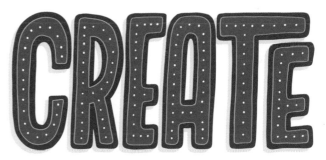

**4.** Use tracing paper to finalize your lettering with a pen, or draw directly over your sketch once the ink has dried. Add in extra details or coloring in this phase.

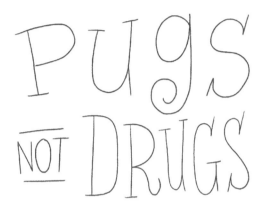

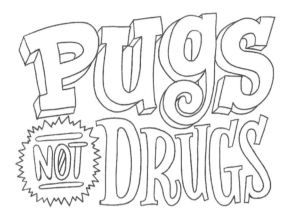

**1.** Let's break away from the traditional grid and go for a more freeform effect. Use a mixture of large and small lettering to add some variation to your lettering composition.

**2.** Using the rough sketch as a guide, draw in each letterform. Sketch in the various pieces that form each letter. Add some dimension and a bursting shape-holding device.

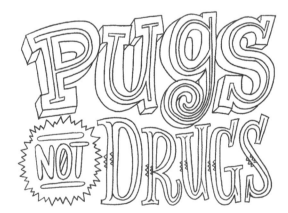

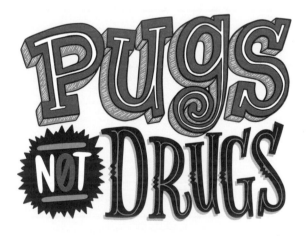

**3.** Continue to layer in lettering details like an inline and some barbs. The more refined this sketch is the better.

**4.** Once you've inked the art, take it a step further and scan it into the computer for colorization. Add in last-minute details and a background color to ground the lettering.

 ADD MORE DETAIL TO LARGER WORDS BUT LIMIT DETAIL ON SMALLER WORDS FOR THE SAKE OF READABILITY.

## DAY 49

### *Detail & dimension*
# STYLE CHALLENGE

Today, let's focus on coming up with new ways to add detail and dimension to your lettering styles. Choose a simple and interesting word to use for your exploration. This is a great exercise to help you come up with your own new styles—how many different styles can you come up with?

**TIP** SKETCH SMALL AND FAST TO COME UP WITH A WIDE VARIETY OF DIFFERENT STYLES.

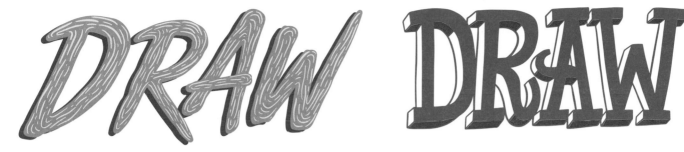

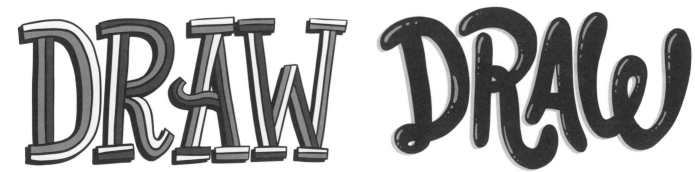

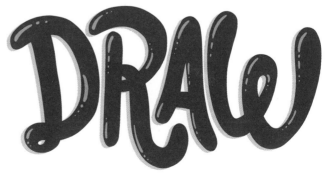

## *Detail & dimension*
# SKETCH-PLORATION

Now that you have a solid handle on some different ways to add dimension and detail, you can use this spread to further practice variations of the style. Try hand-lettering the titles of some of your favorite books and movies. Remember to embrace the imperfections in your hand-lettering!

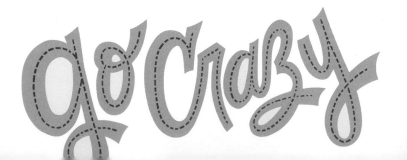

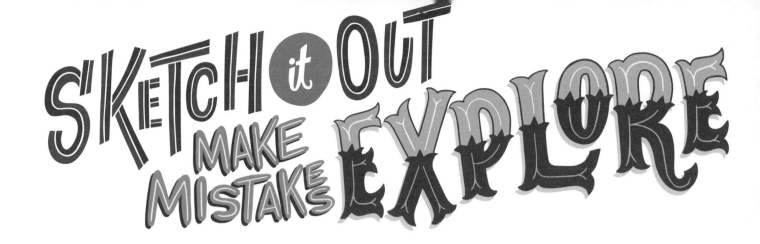

SKETCH it OUT
MAKE MISTAKES EXPLORE

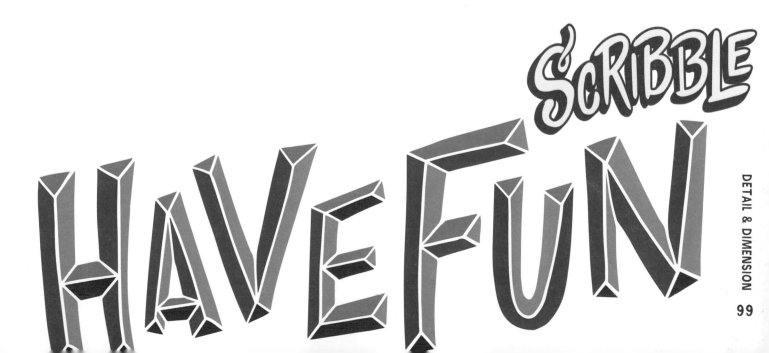

SCRIBBLE
HAVE FUN

# Days 51–60
# FREESTYLE & REPRESENTATIONAL

Although readability can sometimes be a concern, freestyle and representational lettering can be very interesting when used effectively. This section will go over how to create this style of hand-lettering while offering some useful examples along the way.

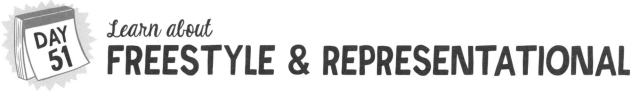

## Learn about
# FREESTYLE & REPRESENTATIONAL

Lettering in a freestyle or representational style can provide some of the most visually pleasing lettering. However, one of the challenges when hand-lettering in these styles is balancing readability and effect to ensure the clarity of the lettering—so use of these styles should be limited to maximize their impact. Check out the visual differences between each style below.

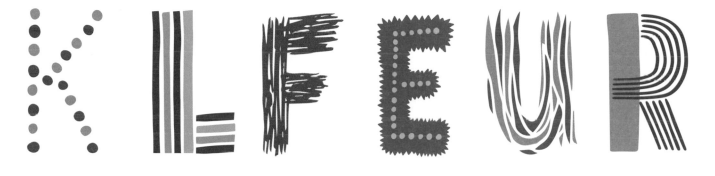

## FREESTYLE

Freestyle lettering is a style of hand-lettering that breaks away from traditional letterform. These letters can be made up of dots, squiggly lines, and scribble. The possibilities are endless as it can truly be made up on the fly.

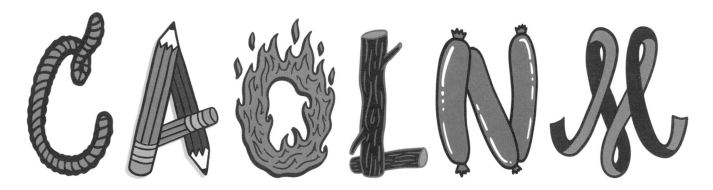

## REPRESENTATIONAL

Representational is a style of hand-lettering that sees each letter take on the appearance of a particular object, like twigs, vines, pencils, rope, ribbons, or dripping water. The more organic and moldable the object is, the easier it is to adapt into letterforms.

# Representational lettering
# PRACTICE PAGE

Ribbon, leaves, and flowers are just a few ways to compose a representational letterform. Use some of the examples I've done as inspiration and see how many different freestyle letters you can come up with using different shapes and objects as a starting idea.

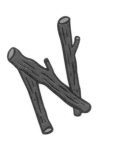
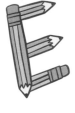

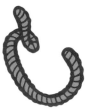

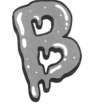

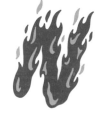

**TIP** BEGIN WITH A PLAIN LETTERFORM. SKETCH AND LAYER DETAIL IN STAGES.

DAY 52

## *Simple step-by-step*
# REPRESENTATIONAL

Today, let's hand-letter a word using a different representational style for each different letterform. Try using some of the different letters you came up with yesterday, or copy the styles below.

**1.** Sketch a simple rectangular grid and some plain letters to be used as guidelines. This will be your foundation.

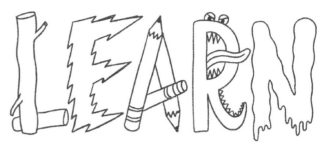

**2.** Start to add in a different styling to each letterform using the foundation you created in Step 1.

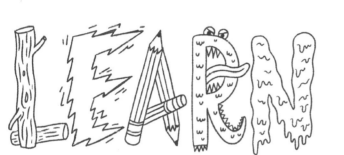

**3.** Layer in more detail in this step. The more refined this sketch is, the easier the final step will be.

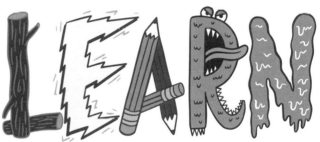

**4.** Use tracing paper to finalize your lettering with a pen, or draw directly over your sketch once the ink has dried. Add in extra details or coloring in this phase.

*Freestyle lettering*
# PRACTICE PAGE

Look around for ideas to use in your representational letterforms. Otherwise, try some of the examples I've done as inspiration and see how many different freestyle letters you can come up with.

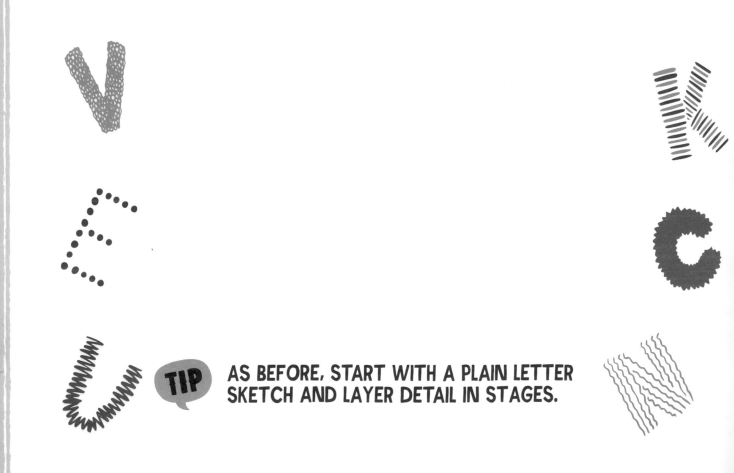

**TIP** AS BEFORE, START WITH A PLAIN LETTER SKETCH AND LAYER DETAIL IN STAGES.

# DAY 55

## *Simple step-by-step*
# FREESTYLE LETTERING

Today, let's hand-letter a word using a freestyle lettering style. Use some of the different freestyle letters you came up with yesterday, or follow along with the style I have lettered below.

**1.** Sketch a simple rectangular grid and some plain letters to be used as a guide. This is your foundation.

**2.** Start to thicken and add weight to each letterform using the foundation you created in Step One.

**3.** Layer in more detail. Allow some of the strokes to overlap others to make the composition more dynamic. The more refined this sketch is, the better.

**4.** Once you've inked the art, take it a step further and scan it into the computer for colorization. Add in last minute details and a background color to ground the lettering.

*Freestyle & representational*
# DRAW YOUR NAME

Try using some of the freestyle and representational styles you practiced over the last few days as inspiration to turn your name into a lettering masterpiece. Use the process we've been practicing to gradually add in layers of detail to bring your representational lettering to life. I decided to draw my name in an ice-block style with snowdrift accents (below), what style are you going to choose?

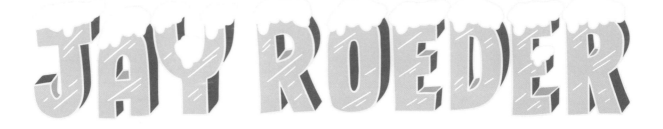

 **STEP BACK A BIT TO EVALUATE YOUR LETTERING TO BE CERTAIN THAT IT IS LEGIBLE!**

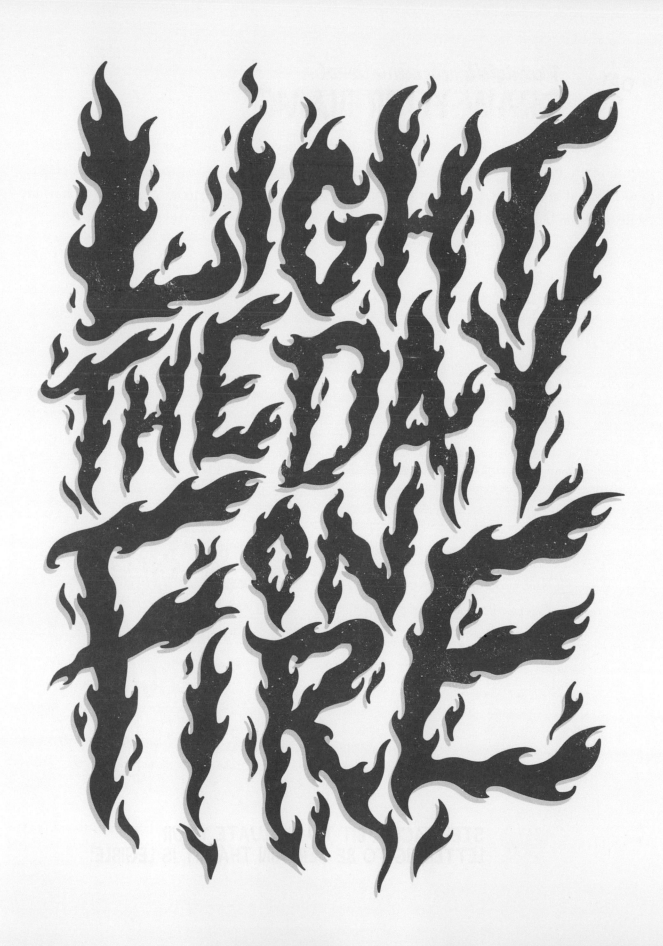

*Step-by-step*
# REPRESENTATIONAL

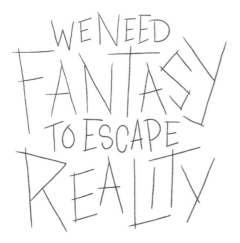

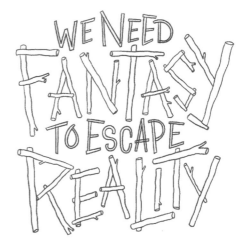

**1.** Now let's break away from the traditional grid and go for a more freeform effect. Use a mixture of large and small lettering to add variation to your lettering composition.

**2.** Start to transform a few of the words into twigs. Allow some of the twigs to overlap others to make it look like they're lying on top of one another.

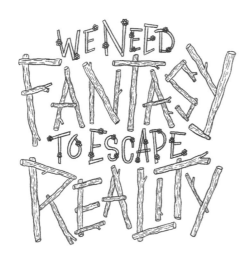

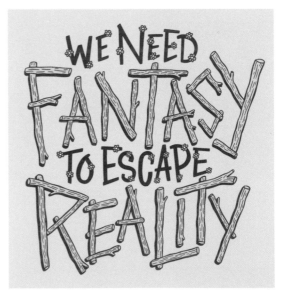

**3.** Layer in details to the twigs and add some flowers to the smaller words. The more refined this sketch is the better.

**4.** Once you've inked the art, take it a step further and scan it into the computer for colorization. Add in last-minute details and a background color to ground the lettering.

 ADD REPRESENTATIONAL DETAILING TO WORDS YOU WANT TO EMPHASIZE AND ACCENTUATE.

# *Step-by-step*
# REPRESENTATIONAL
## WITH CRISTINA VANKO

**DAY 58**

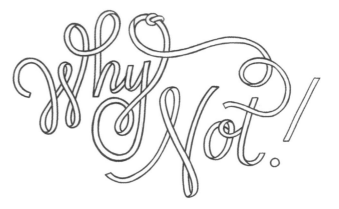

**1.** With representational lettering, have an idea of what you want your letterforms to suggest as you begin. Then, sketch to your heart's desire to see the myriad of options you can create. When you're happy with one of your sketches, draw out the basic shape of the letterforms. From here forward, this outline will act as a skeleton to build upon. I want my letterforms to look like a rope, so I chose script lettering and that way all the letters are connected.

**2.** Because you're working with the letters so much, you tend to see different possible connections your letters could make later on—and that's OK! Be flexible, there's some great stuff that could happen further on in the process. Here, I found different creative ways to connect flourishes and make them more visually appealing. I also added a knot in the "y," because why not? Then, I widened the width and drew to make it have a rope-like appearance.

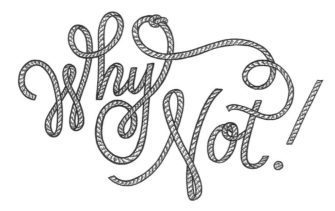

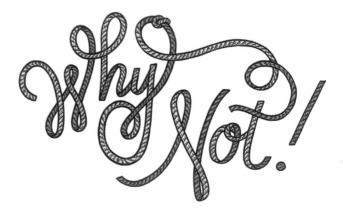

**3.** The devil is in the detail. I could have stopped earlier on, but the drawing could have gotten confused for a ribbon or a shoelace. So I added some lines to mimic way the strands twist in a rope. Not only does this help us to see an actual rope, but it also gives the piece real movement and visual interest.

**4.** Add color! Color helps liven up the lettering enormously. In this instance, color also helps to give the words a dimensional quality and nicely finishes off the piece.

 BE OPEN TO CHANGE AS YOU'RE WORKING ON A PIECE. YOU'LL SEE NEW OPPORTUNITIES FOR FLOURISHES, DETAIL, AND CONNECTIONS AS YOU MOVE FORWARD AND DEVELOP THE WORK.

*Freestyle & representational*
# STYLE CHALLENGE

Today, let's focus on coming up with as many different freestyle or representational styles as you can while using the same word. Use the examples that I created as inspiration to help you come up with your own new ideas. This is a very helpful warm-up exercise to do before starting a project.

**TIP** BE INSPIRED BY YOUR SURROUNDINGS, THEY CAN PROVIDE SO MANY INSPIRING TEXTURES AND VISUALS.

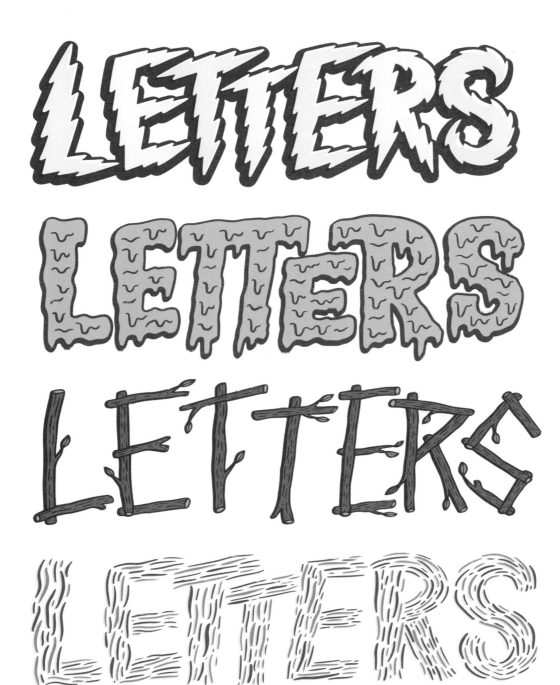

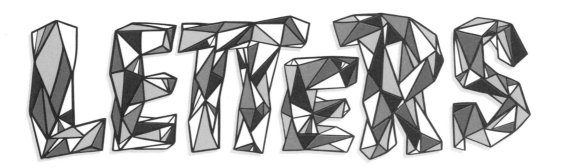

*Freestyle & representational*
# SKETCH-PLORATION

Now that you know some different ways to draw freestyle and representational lettering, you can use this spread to further practice variations of the style. Try hand-lettering some of your favorite quotes or musical lyrics. Remember to embrace the imperfections in your hand-lettering!

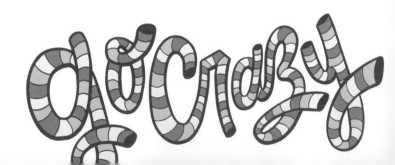

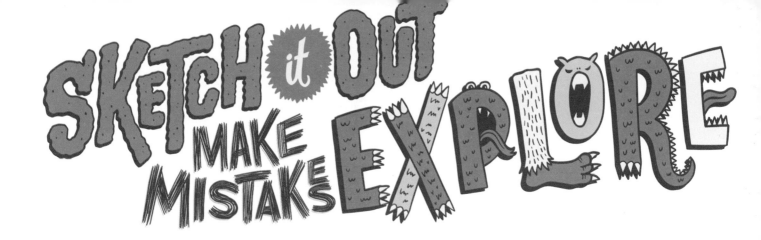

SKETCH it OUT
MAKE MISTAKES
EXPLORE

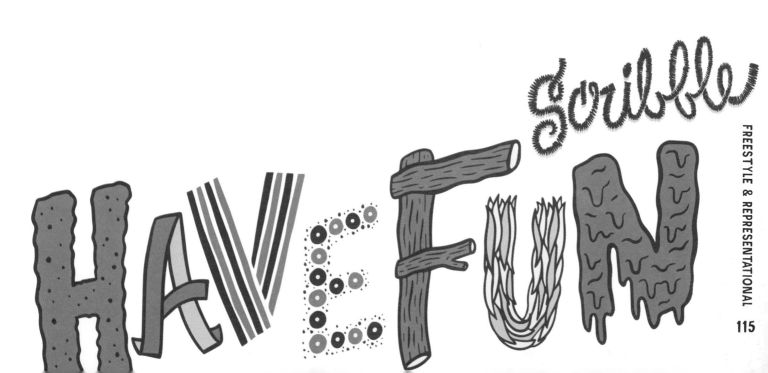

HAVE FUN
Scribble

*Days* 61–70
# INTEGRATED ILLUSTRATION

It's becoming increasingly common to see lettering paired up with illustration. The addition of illustration can greatly enhance a composition, even if it's very simplistic in nature. In this section I'm going to show you how to effectively pair illustration and hand-lettering artwork to create a really dynamic finished product.

# *Learn about*
# COMBINING LETTERING & ILLUSTRATION

Integrating illustration into your artwork is a great way to add interest to compositions and help convey a message in a visually pleasing and even impactful way. Although some illustrative styles can be intimidating, you don't have to have an extremely realistic style to effectively illustrate. Use today to become inspired by all of the fantastic hand-lettering and illustration artwork out there. Check out style sites on the internet, as well as books and magazines.

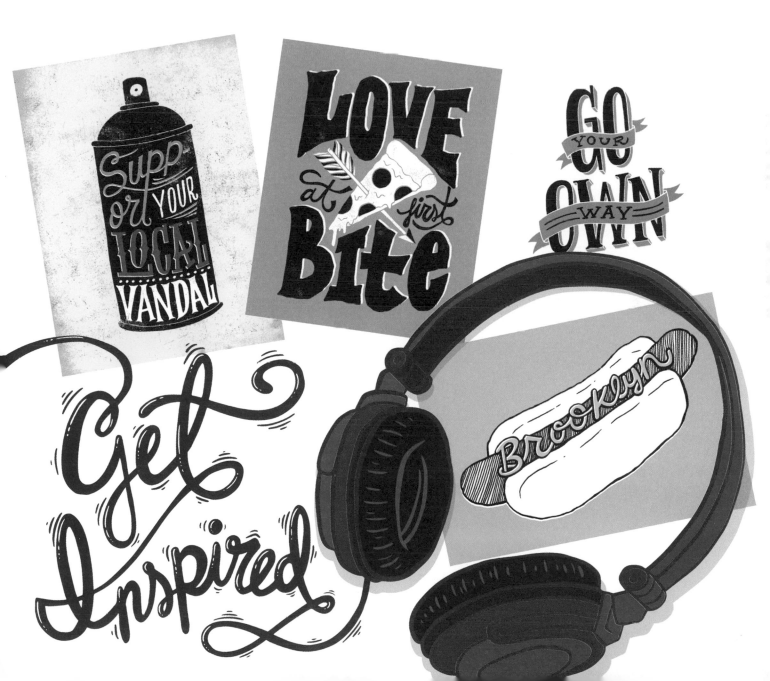

# DAY 62

## *Simple illustration*
# DOODLE PRACTICE

I used to doodle all over my homework when I was in grade school. I didn't realize it at the time, but it really helped me develop my own style. Simple doodles like the ones below can help you hone your drawing skills as you learn to create more complex illustrations. Try sketching donuts, coffee cups, baseballs, and steering wheels. Keep the linework very simple and don't worry about making mistakes.

 **USE A COMBINATION OF THICK AND THIN LINEWORK FOR A NICE EFFECT.**

**DAY 63**

*Simple step-by-step*
# LETTERING IN A SHAPE

Simple illustrations—such as banners—can be worked into a composition to provide emphasis and variation to selected words. Follow along below to learn how to letter inside a ribbon.

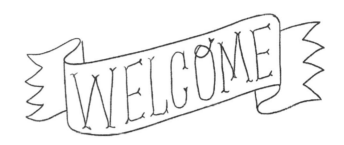

**1.** Start by lightly sketching out a ribbon-like banner shape. Draw it on an angle for a more dynamic appearance.

**2.** Add some lettering to your banner by following the angle of the lines and make sure each letter fills the entire space.

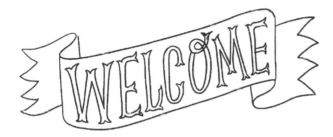

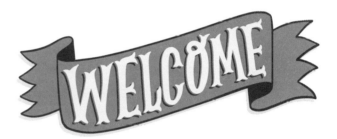

**3.** Thicken and add a split serif style to your lettering. The more refined this sketch is, the easier the final step will be.

**4.** Use tracing paper to finalize your lettering with a pen, or draw directly over your sketch once the ink has dried. Add in extra details or coloring in this phase.

*step-by-step*
# INTEGRATED ILLUSTRATION
## WITH RISA RODIL

**DAY 64**

**1.** Start by doing a rough sketch of your composition. Determine the best way to integrate the illustrations but without overpowering your lettering.

**2.** Using the rough sketch as a guide, draw in each letterform and define the details of the illustrations.

**3.** Continue to add details to the letters. Sprinkle more leaves around the composition to fill up empty spaces if needed.

**4.** Once you've finalized the art, scan it into the computer for colorization. Do some last minute final touches then add a background color to ground the lettering.

 **INTEGRATE ILLUSTRATIONS THAT RELATE TO THE CONCEPT OF YOUR CHOSEN PHRASE. FOR EXAMPLE, A LAYOUT ABOUT READING CAN HAVE BOOKS, READING GLASSES, OR COFFEE CUPS AROUND THE LETTERING.**

## *Integrated illustration*
# ARCHED LETTERING

The combination of arched lettering and an illustration is a very common compositional trick that is relatively easy to execute. First, practice lettering in the arched guidelines below. Start with simple wireframe lettering and be sure to follow the curve of the shape as you plan out the composition. Add a simple illustration as a finishing touch between the shapes as I've done below.

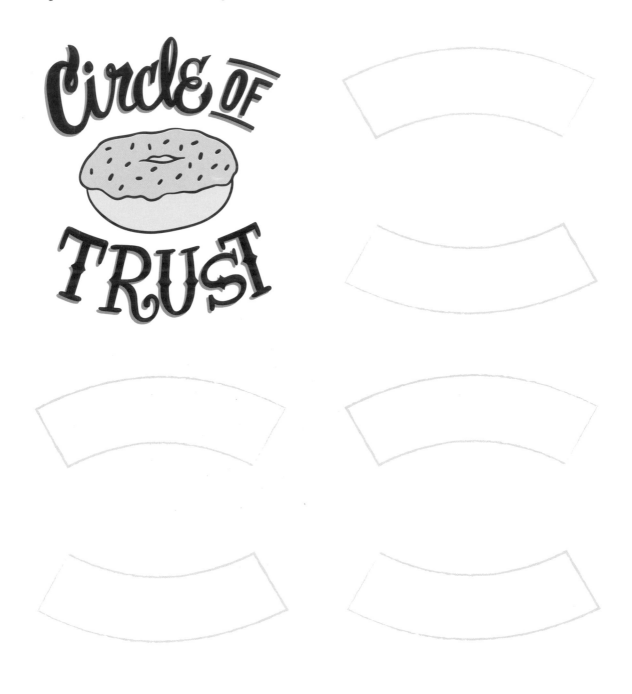

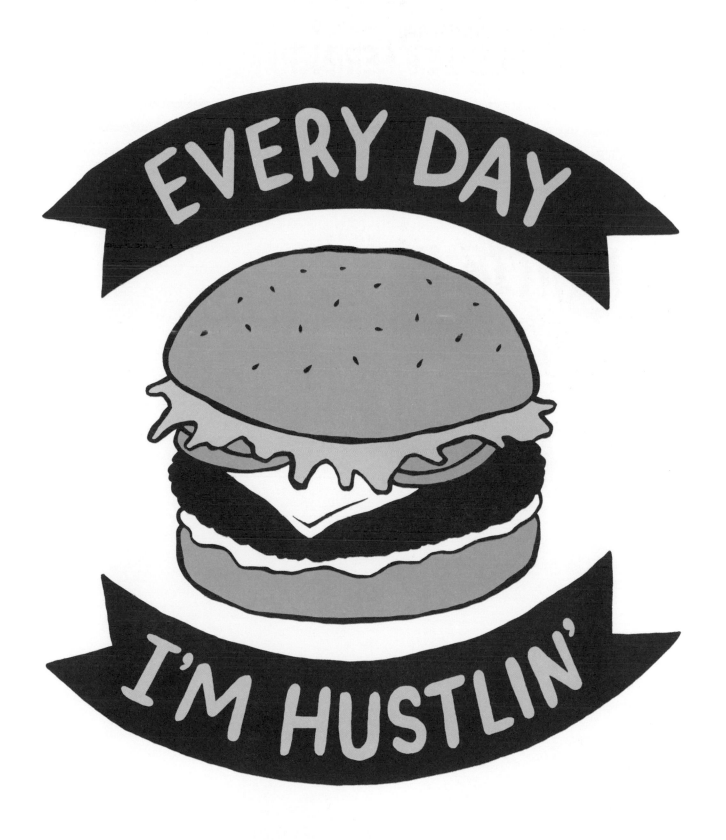

*Integrated illustration*
# SILHOUETTE LETTERING

These last few days we have practiced hand-lettering into simple shapes, so today let's take it a step further and practice lettering into some more complex shapes. Think of a simple phrase and use light sketching to plan it out. Fill the entire shape and use a combination of ascenders, descenders, flourishes, and illustrations to use up all the space. The finished results are always interesting and unique.

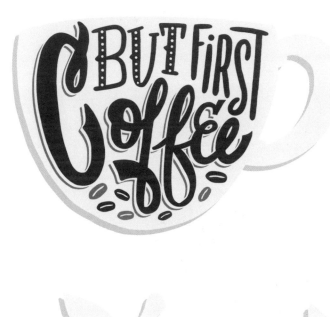

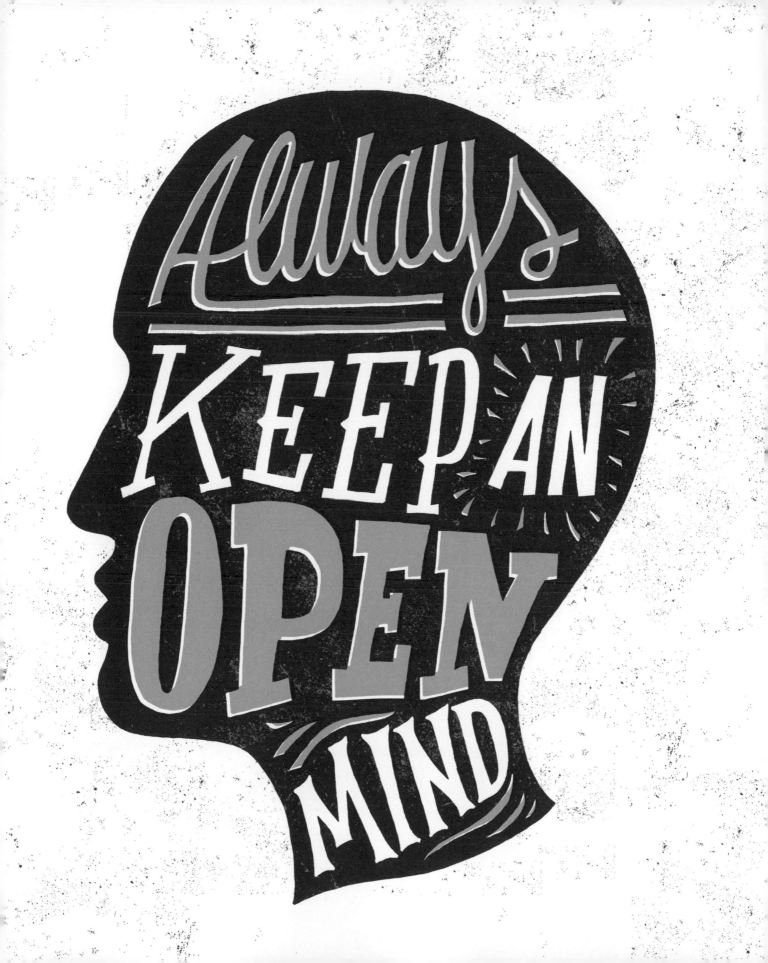

*Step-by-step*
# LETTERING IN A SHAPE
## WITH IAN BARNARD

DAY 67

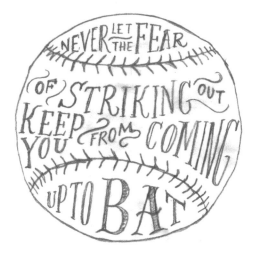

**1.** Find a photo of an object and trace round it with a pencil. Keep this sketch very simple, with minimal detail.

**2.** Use a pencil to add your words inside the object. Use an eraser to refine and revise. I tend to use a mixture of uppercase serif and sans serif letter styles.

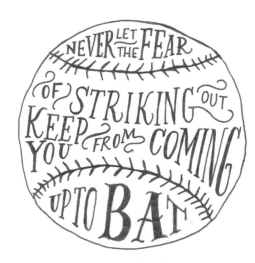

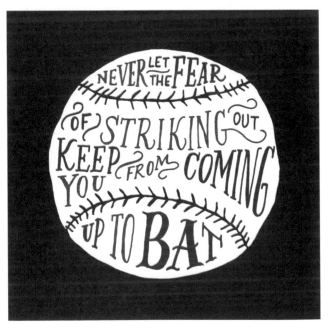

**3.** Once you're happy with the layout go over it with a pen on a fresh sheet of tracing paper, or in ink over your sketch. When the ink has dried, erase the pencil sketch.

**4.** Take your art a step further and scan it into the computer for colorization. Image trace the final drawing and add some color to make it stand out.

 **TRY TO FILL THE ENTIRE SHAPE WITH LETTERING AND FLOURISHES AS YOU PLAN OUT YOUR COMPOSITION.**

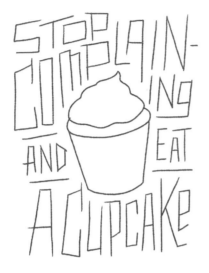

**1.** Start by drawing a simple illustration, then let the lettering surround the illustration. For this piece use a rigid and angular style of illustration for emphasis.

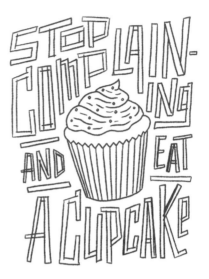

**2.** Using the rough sketch as a loose guideline, start to draw in each letterform. Try to maintain the same thickness for each letterform. Then add detail to the illustration.

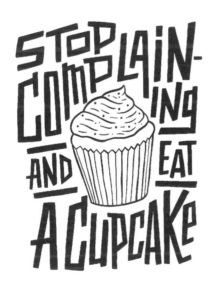

**3.** Use tracing paper to finalize your lettering with a pen, or draw directly over your sketch once the ink has dried.

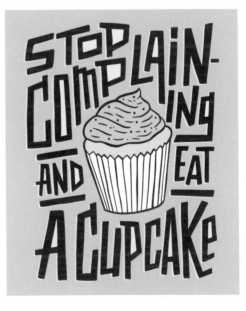

**4.** Take the artwork a step further and scan it into the computer for colorization. Add in last-minute details and a background color to ground the lettering.

 **KEEP THE SPACING BETWEEN LETTERS VISUALLY EQUAL TO MAINTAIN CONTINUITY IN YOUR COMPOSITION.**

## DAY 69

### *Lettering in a shape*
# STYLE CHALLENGE

Think of a few interesting silhouette shapes and some phrases to fill them. Focus on filling each shape with lettering like the examples on the next page. Start out with simple shapes such as apples and stars, then work your way up to more complex and interesting silhouettes.

**TIP** ALWAYS START BY LIGHTLY SKETCHING OUT
A SHAPE BEFORE YOU ADD THE LETTERING.

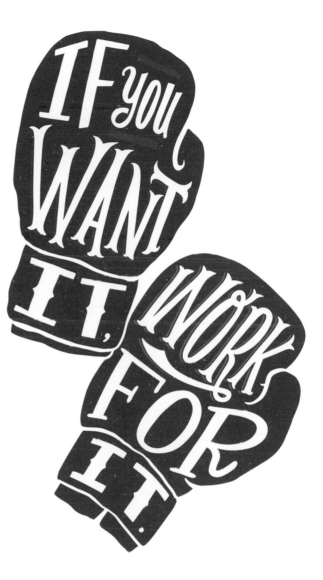

Shine Bright

If you WANT it, WORK FOR IT.

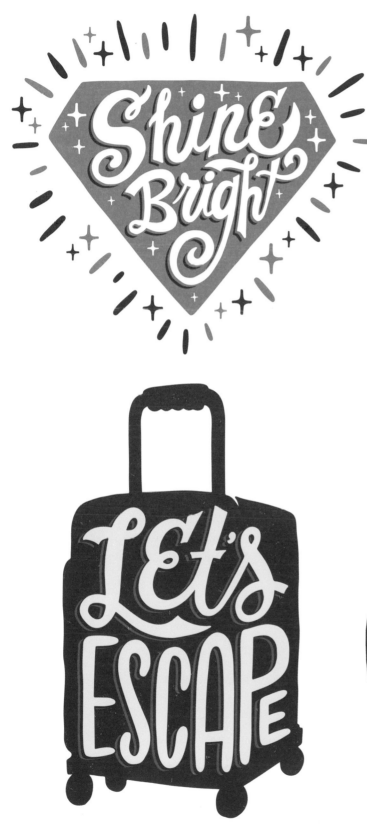

Let's ESCAPE

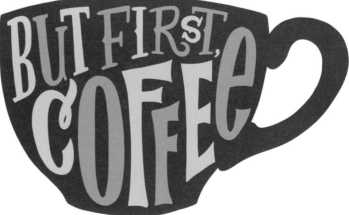

BUT FIRST, COFFEE

*Integrated illustration*
# SKETCH-PLORATION

Now that you know how to integrate illustrations into your hand-lettering compositions, you can use this spread to further practice this style. Think of some simple phrases and pair them up with illustrations like the examples on this spread.

SKETCH it Out
make Mistakes
EXPLORE

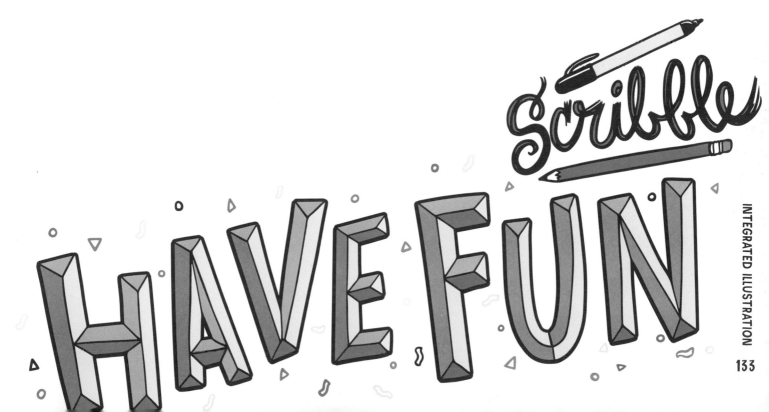

Scribble

HAVE FUN

*Days* 71–80
# BORDERS & PATTERNS

Adding a border or pattern to your hand-lettering composition can give it just the right finishing touch. This section will teach you about the process of creating borders and patterns, and how to integrate them into your hand-lettering artwork.

# DAY 71

## *Learn how to*
# CREATE A BORDER

Today, let's go over the process of how to create a border. We're going to focus on a straight-line portion of the border. The key with drawing borders is to take your time and gradually layer in detail and color as you build it up. Use this approach with ornate borders like the one featured below, or more simplistic frame-styled borders. Start with a simple line or shape and build it up. It's easy!

**STEP 1**     Start with a simple wavy line. Thicken the stroke by drawing over it a few times to make it a bit more visually interesting.

**STEP 2**     Gradually layer in some leaves. Use a mixture of large and small leaves, and try to maintain similar spacing between them.

**STEP 3**     For the final step, add some detail to the leaves plus some fun colors. Fill some of the gaps with some smaller curvy vines.

**TIP**     ONCE YOU HAVE THE PROCESS DOWN, TRY ADDING SOME INTERESTING CORNER TREATMENTS TO YOUR BORDERS.

*Practice page*
# SIMPLE BORDERS

Yesterday we learned about the process of creating a border. Today, let's put those ideas to work! Come up with some borders below. But keep them simple at first as you learn to build them up.

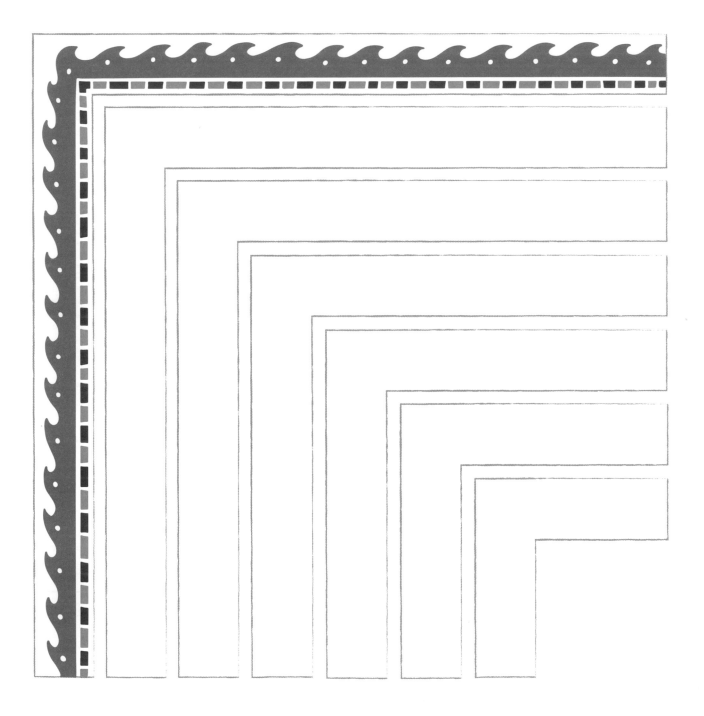

# Practice page
# BORDERS WITH OBJECTS

Some of my favorite borders include objects. Choose a few different things like pizza, leaves, or cupcakes and create some borders in the space below. I like to start out by drawing the objects and then add linework or shapes to connect the objects together. What's your favorite junk food—pizzas, donuts, burgers? Start out with that!

# DAY 74

*Simple step-by-step*
# BORDER & LETTERING

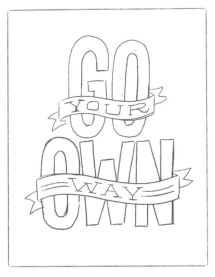

**1.** Use the process we've established to create a simple lettering composition. Use a mixture of large and small-sized lettering to keep your composition interesting.

**2.** Add some corner accents to all four corners of the composition. These will serve as the anchor points for your border. Then throw some final letter details in as well.

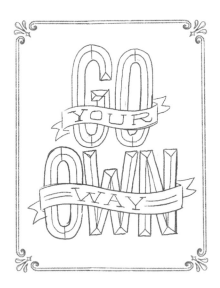

**3.** Now it's time to join your corner accents together. Add a long straight line to connect your border on each side.

**4.** Take the artwork a step further and scan it into the computer for colorization. Add in last-minute details and a background color to ground the lettering.

 TRY TO FIGURE OUT YOUR HAND-LETTERING COMPOSITION BEFORE YOU ADD A BORDER.

*step-by-step*
# BORDER & LETTERING

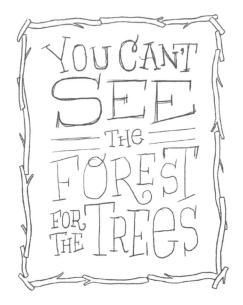

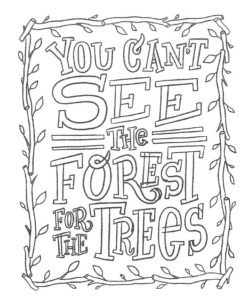

**1.** Start by drawing a simple lettering composition. Add some twigs to serve as a border. Keep the sketch very loose as you plan it out.

**2.** Thicken the weight of your lettering composition and start to layer in dimension and small leaves to your border.

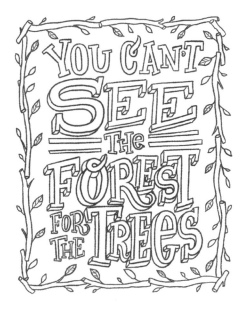

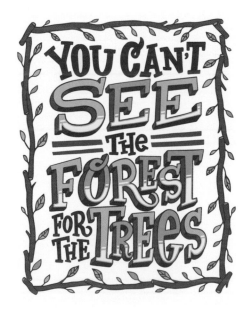

**3.** Use tracing paper to finalize your lettering with a pen, or draw directly over your sketch once the ink has dried.

**4.** Take the artwork a step further and scan it into the computer for colorization. Add in last-minute details and a background color to ground the lettering.

**TIP** LIMIT YOUR COLOR PALETTE TO THREE OR FOUR COLORS THAT COMPLEMENT ONE ANOTHER.

# How to CREATE A PATTERN

When you look at patterns—such as the ones below or to the right—you might assume they are too complex to achieve, but they really aren't. As with borders, creating a pattern is all about gradually layering in shapes and details. Even the most complex patterns start out quite simply. Just take a look at the steps below to see what I mean.

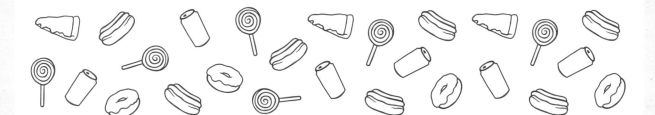

## STEP 1

I like to start out by choosing a few objects or shapes. Repeat them throughout your space and try to maintain a similar spacing between each object. Keep the artwork relatively simple in this phase.

## STEP 2

Now that you're happy with the spacing and choice of objects, you can start to layer in some detail to each individual shape.

## STEP 3

For the final step, add in some shapes to help fill the negative space. I like to use very simple geometric shapes to do this, as shown above.

# Practice page
# SIMPLE PATTERNS

Now that you've learned what goes into creating a pattern it's time to devise some of your own. Draw some very simple patterns in the empty spaces below. I've started a few for you to use as inspiration. Work with markers to bring in some interesting color combinations. How many different simple patterns can you come up with?

## PATTERNS WITH OBJECTS

Yesterday we practiced simple patterns, which means today we're going to try creating some more detailed patterns. Think of a few themes to guide your pattern exploration for the spaces below. Remember to start out with a light sketch of the more prominent objects in your pattern, and gradually layer in detail and smaller shapes to fill the negative space. Try using a mixture of two or three colors.

# DAY 79

## *Step-by-step*
# PATTERN & LETTERING
## WITH TIM EASLEY

**1.** First, roughly sketch out the letters, then thicken and outline them, adding under and over elements to give the letters more life. This is where most of your editing will happen. Experiment and play with things, until you have a design you're happy with.

**2.** Now add in the doodles. Make sure you give yourself enough space, and try to strike a good balance between getting enough detail in there but not making the design look too cluttered. This can be a little tricky, but work at it!

**3.** Next bring the design into the computer, and trace the outlines of the lettering and doodles. Here you can do a little more editing, and maybe move some of the doodles around to better fit the space.

**4.** Lastly you can fill in some color. Try to spread things out so that there aren't too many adjacent shapes with the same color, that way the design will look more balanced. Once you're done with this you can play with things like offsetting the color a little as I've done here.

**TIP** LOOK AROUND YOUR ENVIRONMENT FOR DIFFERENT SHAPES AND PATTERNS TO USE IN YOUR DOODLES.

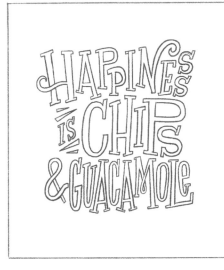

**1.** Use the process we've established to create a simple lettering composition. Use a mixture of large and small-sized lettering to keep your composition interesting.

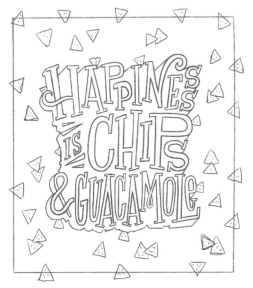

**2.** Add some tortilla chips around the letters to serve as a pattern. Let some of them drift off each edge. Add some dimension to the lettering lockup to add emphasis to it.

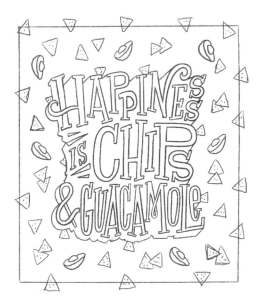

**3.** To provide variation to the pattern, add in a few avocados to play off the theme. Tighten up the lettering and pattern as you prepare to take the art to color.

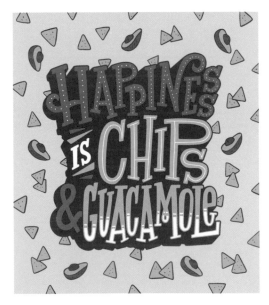

**4.** Once you've inked the art, take it a step further and scan it into the computer for colorization. Add in last-minute details and a background color to ground the lettering.

 **TRY TO CHOOSE A PATTERN THAT PLAYS OFF THE THEME OF YOUR CONCEPT.**

# Days 81-90
# COMBINED STYLES

Combining styles is one of the most exciting aspects of hand-lettering, but you need to have a solid grasp of a number of foundational styles in order to do it. Luckily we've covered a plethora of different styles up to this point! This section will hit you with plenty of inspiration and some solid tips to help you have fun with combined styles.

# Combined styles
# DRAW YOUR NAME

We've covered a ton of styles thus far and now it's time to combine some of them into a single hand-lettering composition. Try hand-lettering your name in a couple of the different styles suggested below. Choose two of them, or two from earlier in the book. Think about which ones might complement each other. I like to pair up cursive script with simpler styles, like sans serif. Just have fun with it!

*Simple step-by-step*
# COMBINE TWO STYLES

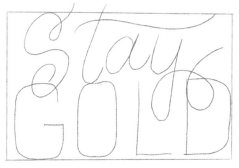

**1.** Start by sketching out each word in plain lettering. Allow the script style to overlap and interact with the sans serif.

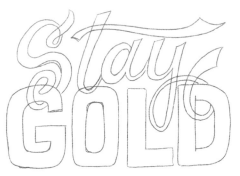

**2.** Start to thicken the composition. Continue to plan out how the script will go behind and in front of the sans serif lettering. This will make it much more dynamic.

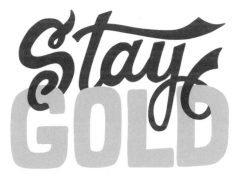

**3.** Ink the lettering and bring in an additional color like gold to visually create separation between the two styles.

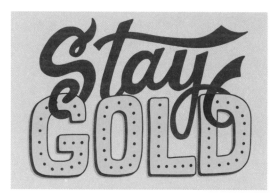

**4.** Finalize your artwork by working in additional lettering details and a background color to help bring it to life.

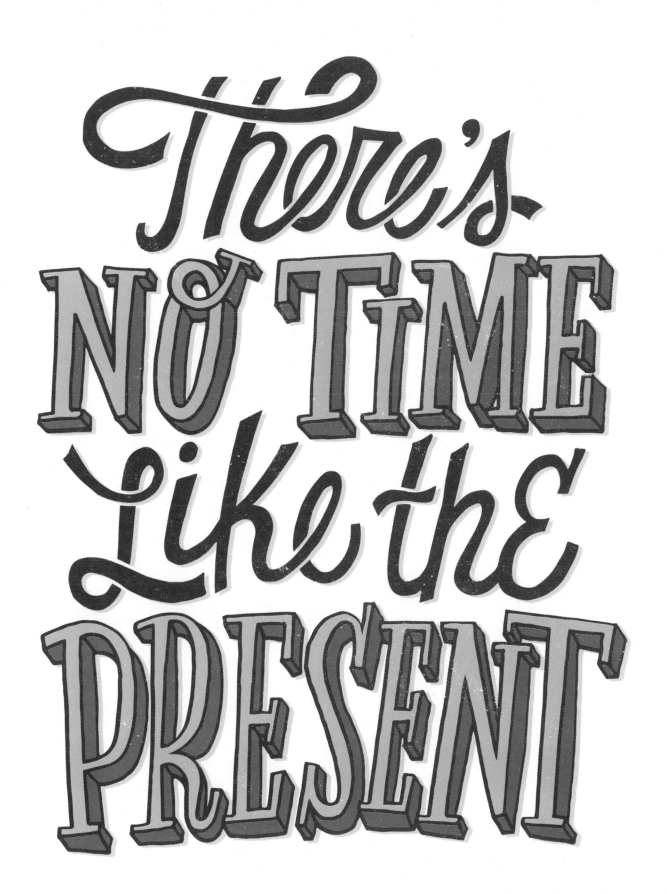

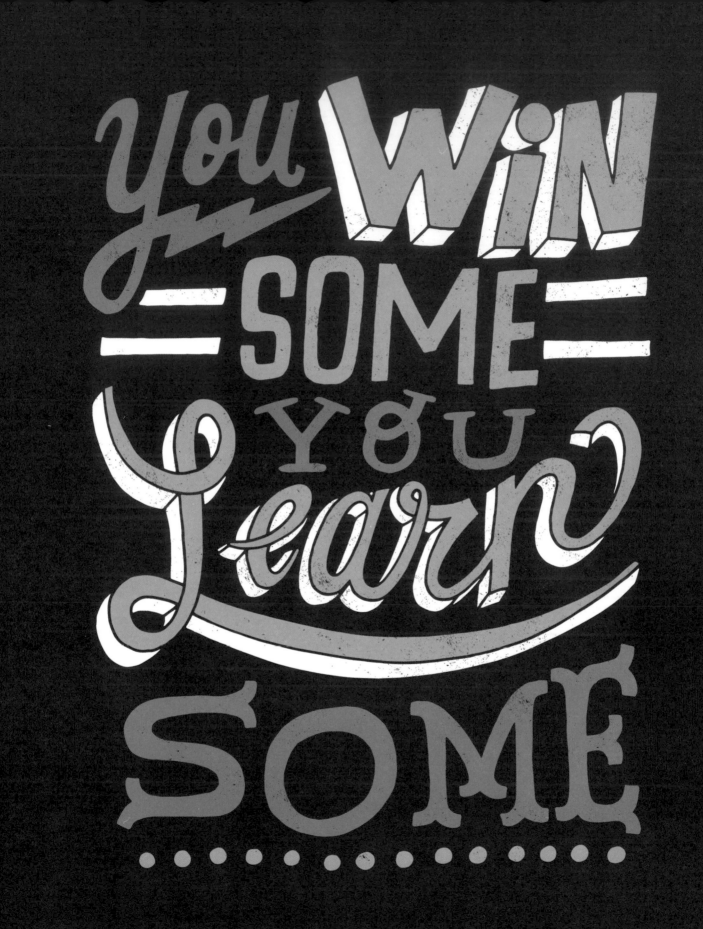

## Practice page
# COMBINE THREE STYLES

We've tried combining two styles, now let's add a third style to your composition. Think of a short phrase to use and then interesting ways to make those styles interact—such as letting them overlap or curl around each other. For longer phrases, use a mixture of large and small lettering.

 **TIP** **COMBINING STYLES THAT COMPLEMENT ONE ANOTHER WILL MAKE YOUR COMPOSITIONS MORE DYNAMIC.**

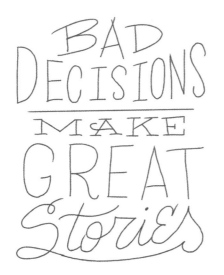

**1.** Let's break away from the traditional grid and go for a more freeform effect. Use a mixture of large and small lettering to add some variation to your lettering composition.

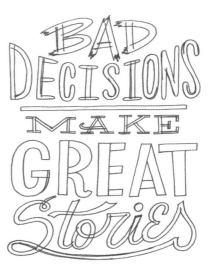

**2.** Using the rough sketch as a loose guideline, start to draw in each letterform. Mix up the height, width, and thickness of each styled word for a more dynamic appearance.

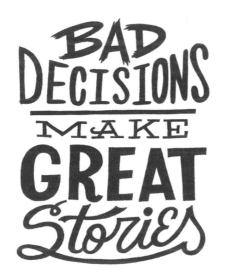

**3.** Use tracing paper to finalize your lettering with a pen, or draw directly over your sketch once the ink has dried.

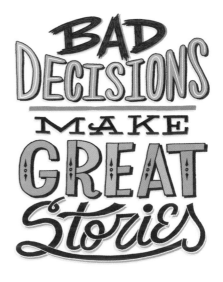

**4.** Take the artwork a step further and scan it into the computer for colorization. Add in last-minute details and a background color to ground the lettering.

 ADDING IN DIVIDERS, BARS, AND DOTS CAN HELP BREAK UP LONGER PHRASES AND GIVE A SENSE OF VISUAL RELIEF.

*Step-by-step*
# COMBINED STYLES
## WITH SHAUNA LYNN PANCZYSZYN

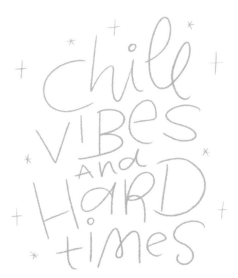

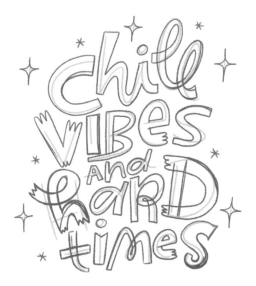

**1.** In this example, we are treating our letters more like music, with emphasis on some letters and a variation in styles and sizes. Start by drawing a very loose skeleton of your phrase.

**2.** Begin blocking in your shapes by using a mix of thick and thin strokes. I like to use a darker color when doing this to differentiate it from the skeleton. You can also play with different end caps on your letters for more variation.

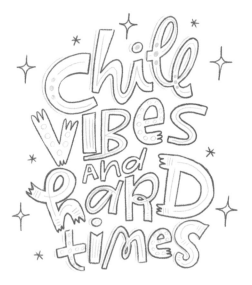

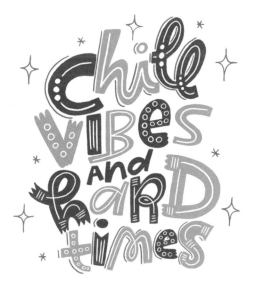

**3.** Here is where you can erase and refine your sketch. Clean up any stray lines and get the lettering defined. Using another color, add in some random patterns and inlays to your letters and just have fun with the details.

**4.** Taking this a step further, ink your drawing and then scan it into the computer to colorize it. Playing with varying contrasts in colors will further emphasize the freeform lettering and really make it shine!

 **DON'T BE AFRAID TO CHANGE YOUR LETTERS AND STYLES AS YOU GO.**

*Combined styles step-by-step*
# LETTERING IN A SHAPE

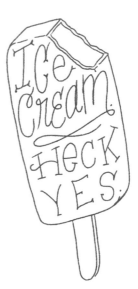

**1.** Start by drawing a simple illustration to provide a shape to letter inside. Keep this illustration very loose.

**2.** Begin lettering inside the shape you drew in Step 1. Try to fill the entire shape. Adding letter flourishes can help you fill any tough negative spaces, as seen above.

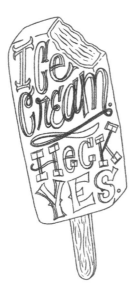

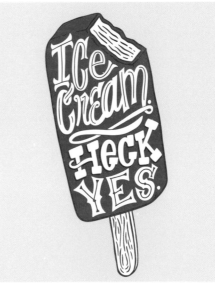

**3.** Thicken the weight of your lettering and add in extra details to the illustration to further bring it to life. The more refined this sketch is, the easier the final step will be.

**4.** Once you've inked the artwork, scan it into the computer for colorization. Add in last-minute lettering details and a background color to ground the composition.

 **SIMPLISTIC SHAPES THAT HAVE LARGE OPEN AREAS TYPICALLY WORK BEST TO CONTAIN LETTERING.**

*Combined styles*
# ANGLED LETTERING

Adding a simple angle to your lettering can dramatically increase the appeal and impact of a composition. It can be easy to overdo: sometimes all you need is a slight angle to achieve a dynamic effect. Practice filling each of the angled grids below with your hand-lettering.

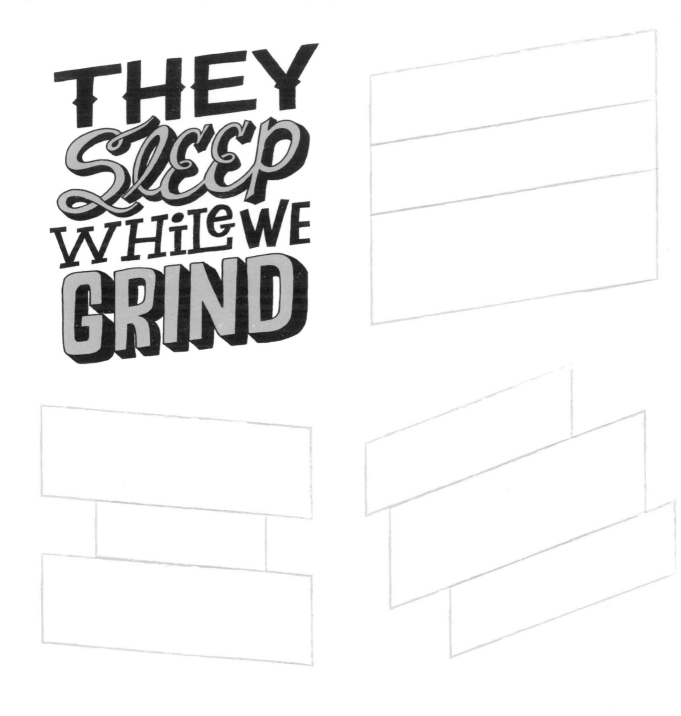

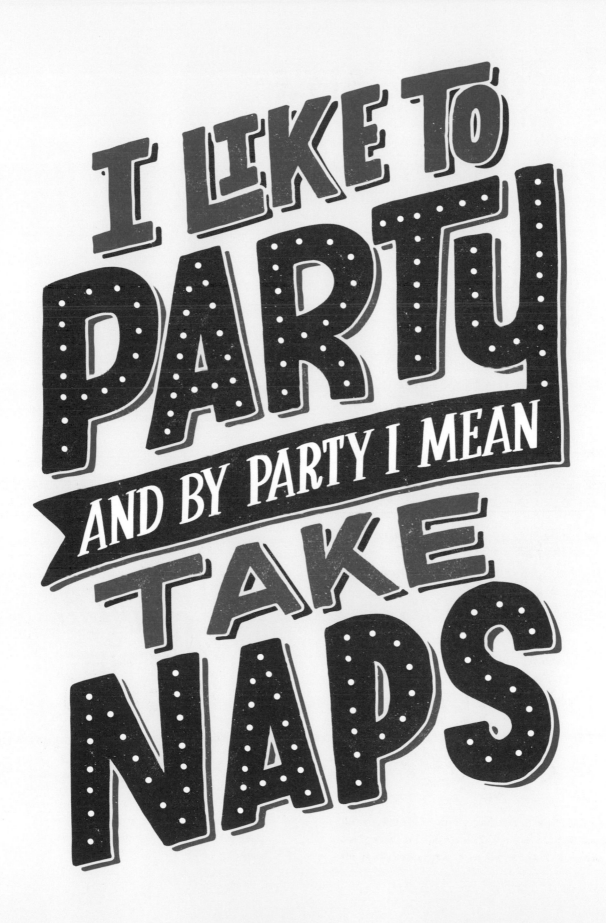

**1.** Sketch out the words for your phrase as quickly as you can. Play around with placement until you have an idea of the general space that each word will occupy, keeping in mind the overall rhythm and balance of the piece.

**2.** Start fleshing out your sketch, staying true to your general outline, but now alternating between styles for each word. (You may also want to keep short phrases the same style.)

**3.** Don't be afraid to switch up a word's style to better fill the space! Sometimes you'll discover that the shape of your word works better in one style than it does with another.

**4.** Embellish and experiment with different color combinations to find something that serves the theme of your work.

**TRY UNUSUAL SHAPE COMBINATIONS TO
SHAKE YOU OUT OF YOUR COMFORT ZONE.**

*Combined styles*
# STYLE CHALLENGE

Today, focus on coming up with as many different combined lettering lockups as you can while using the same phrase. This is a great exercise to help you figure out which lettering styles best complement one another. Sketch small and fast to create a wide variety of different options.

**TIP** IF TWO STYLES ARE NOT WORKING TOGETHER, THINK OF WAYS TO UNIFY THEM USING COLOR AND DETAIL.

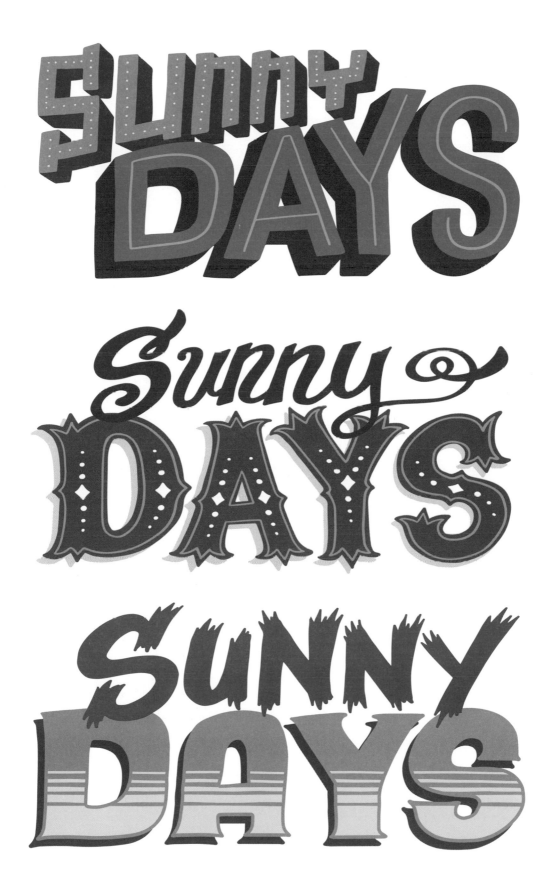

*Step-by-step*
# COMBINED STYLES WITH ILLUSTRATIONS

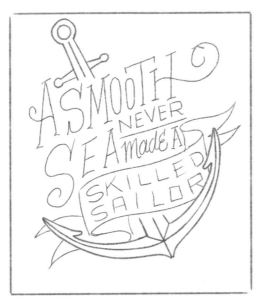

**1.** Start by drawing a simple illustration of an anchor. Flow the lettering inside the illustration. Emphasize the most important words by containing them inside the banner.

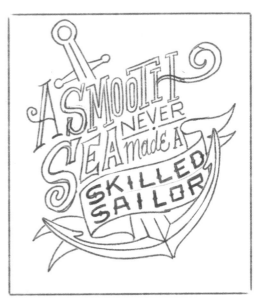

**2.** Using the rough sketch as a loose guideline, start to draw in each letterform. Try to maintain the same thickness for each letter. Work in detail to the illustration.

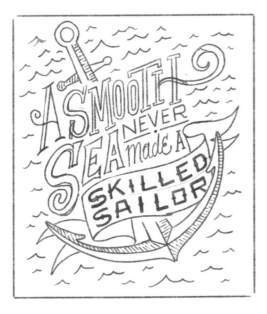

**3.** Add additional lettering and illustration details. Fill out the negative space with a wave pattern around the entire composition. The tighter this sketch is the better.

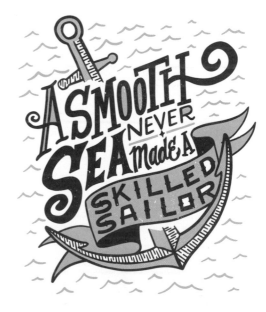

**4.** Once you've inked the artwork, scan it into the computer for colorization. Add in last-minute lettering details and a background color to ground the composition.

**FILL IN THE COUNTERSPACES OF YOUR LETTERING TO UNIFY THE COLOR PALETTE IN YOUR COMPOSITION.**

## Days 91-99
# REAL WORLD APPLICATIONS

We've covered a lot of ground so far, now it's time to see how effective hand-lettering can be when used on client projects. This section will focus on how hand-lettering can be applied to real world projects like T-shirt designs, show posters, book covers, logos, greeting cards, and more. Using the solid foundation of lettering you've established, you should have no problem impressing clients.

# WORKING WITH CLIENTS ON PROJECTS

Years back, when my first real client project came in, I was scared to death. I overdelivered as a result, which is not entirely a bad thing, but also not an efficient use of my time. Today, I spend most of my time in the research and sketch phase of each project. Don't underestimate the power of thorough research. For example, if you're doing a mural for Minneapolis, Minnesota, establish a good understanding of the culture surrounding the area before you start sketching concepts. Ask your client plenty of questions up front, to assure you have a solid understanding of the scope of the project. I typically come in with two to three sketch options for most projects. Getting your client to commit to a given option before bringing it to color will save you a ton of time. A good client relationship is more of a collaboration. Remember to be confident and always keep an open mind. You've got this!

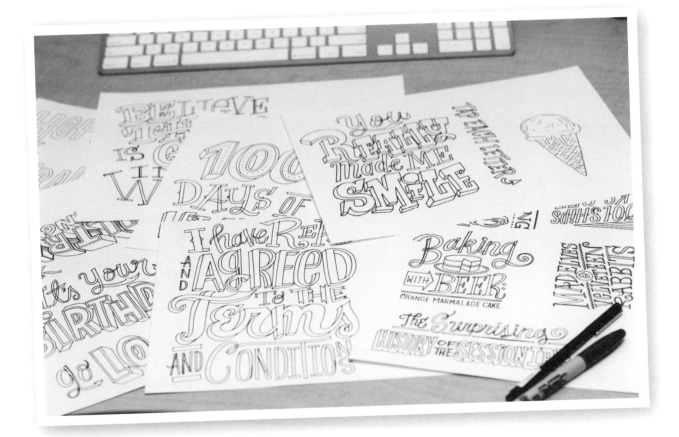

 **TIP** **SOLID RESEARCH BUILDS CONFIDENCE AND PROVIDES LOTS OF INSPIRATION FOR YOUR CLIENT PROJECTS.**

*step-by-step*
# HAND-LETTERED LOGO

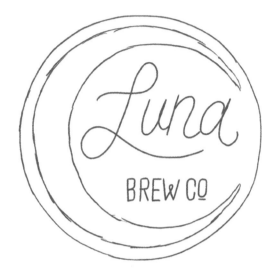

**1.** Start out by drawing a simple illustration of a moon. Be sure to keep this sketch very loose, as it will be tightened up in subsequent steps.

**2.** Use a simple script lettering for the name of the drink and a sans serif style for the company name. Sketch in an outer edge around the entire logo lockup.

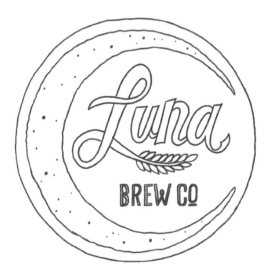

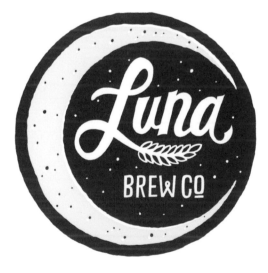

**3.** Thicken the lettering and add details to the moon. Add an illustration of a wheat ear to the tail of the letter "L." The tighter this sketch is the easier the final step will be.

**4.** Once you have inked the logo, scan it into the computer. Add any last-minute details and color it. Try to limit the number of colors you use for your logo. Simple is best.

**TIP** HAND-LETTERED LOGOS SHOULD ALWAYS BE CONVERTED TO VECTOR POINTS TO INSURE INTEGRITY AT ANY SIZE.

*Step-by-step*
# GREETING CARD

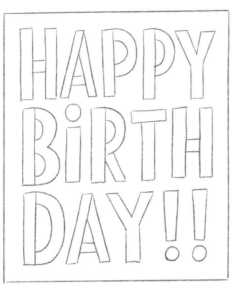

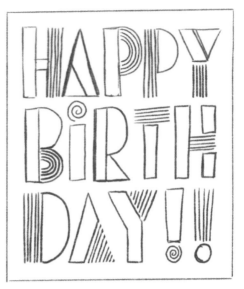

**1.** Start by sketching a simple square grid. Lightly draw in your lettering, and keep it very loose. The finished product will look very different from this skeleton lettering.

**2.** Using the rough sketch as a guideline, start to draw in each letterform. We're using the freestyle approach here, so legibility is not as much of a concern.

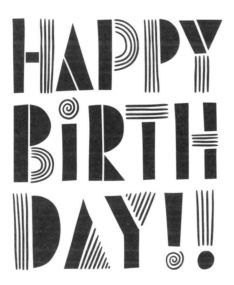

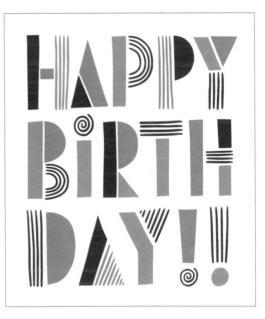

**3.** Use tracing paper to finalize your lettering with a pen, or ink directly over your sketch. Erase the sketch once the ink has dried. Be sure to maintain space between each freestyle shape.

**4.** Take the artwork a step further and scan it into the computer for colorization. Add in last-minute details and a background color to ground the lettering.

 **VARY YOUR COLOR PLACEMENT TO MAINTAIN A VISUAL BALANCE THROUGHOUT THE COMPOSITION.**

*step-by-step*
# T-SHIRT DESIGN
## WITH FRANCES MACLEOD

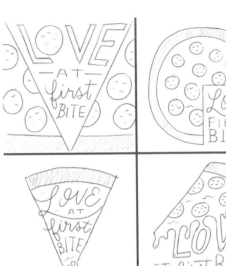

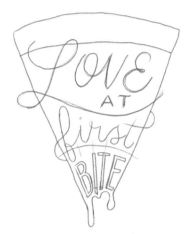

**1.** Make a few sketches of your concept trying different compositions to see what will most effectively communicate your idea. Sometimes your first idea is your best, but not always!

**2.** Draw your favorite sketch larger, giving particular care to the placement of the letters. It can be helpful here to use tracing paper on top of your illustration to play with different line breaks and character sizes.

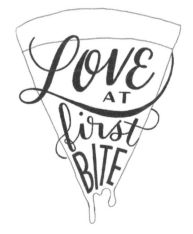

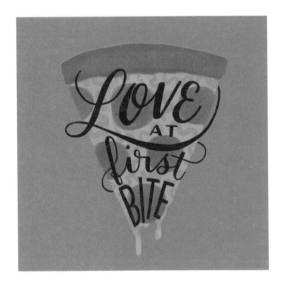

**3.** Make a rough sketch to scale so you can plot where the letters will go, drawing whatever guidelines you need to help space the characters. Again, it can be helpful to layer tracing paper to play with different sizes.

**4.** If you decide to finalize it as a digital piece, scan your illustration and type separately. Layer them in a design program, so you can move letters around, and clean things up until it's just right.

 **WHEN MIXING DIFFERENT TYPES OF LETTERFORMS SUCH AS SCRIPT AND BLOCK, PAY ATTENTION TO THE BALANCE OF THE VISUAL WEIGHT OF EACH STYLE AGAINST THE OTHER.**

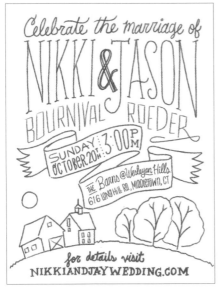

**1.** In plain lettering, start to lay out your composition. Work your way from top to bottom and don't be afraid to get messy, as this will only serve as a base layer to work from.

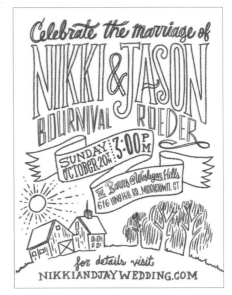

**2.** Once you're happy with your loose sketch, start to add weight and styling to your letterforms. Layer in some more detail to the illustrative elements at the bottom of the design.

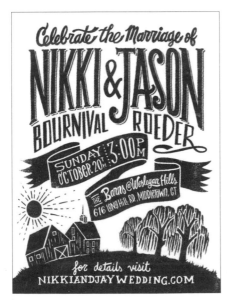

**3.** Use tracing paper to finalize your lettering with a pen, or ink directly over your sketch. Erase the sketch once the ink dries. Try using a white pen for lettering that sits on darker colors.

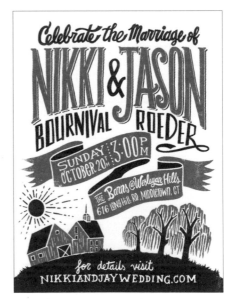

**4.** Take the artwork a step further and scan it into the computer for colorization. Add in last-minute details and a background color to ground the lettering composition.

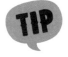 **USE A MIXTURE OF LARGE AND SMALL LETTERING IN DIFFERENT STYLES TO CREATE A MORE DYNAMIC LETTERING COMPOSITION.**

*Step-by-step*

# BOOK COVER DESIGN
## WITH JOEL FELIX

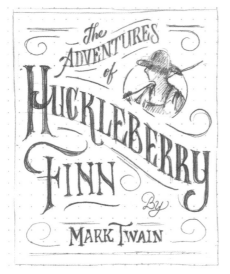

**1.** My first step is to sketch a rough composition, I like to use a dot grid paper to give me a sense of scale and position. I'll scan this thumbnail and print it up enlarged by about 200 percent so that I can trace over it.

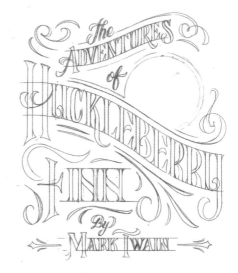

**2.** Next I'll use a new sheet of paper and a light box to refine my line work and letter spacing. I start with the vertical stems, then go back and add serifs to all the letters. I also begin to refine the flourishes and filigree at this step.

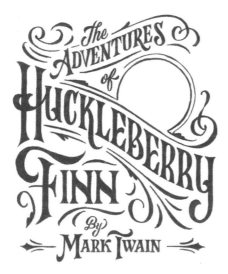

**3.** Once I have a good skeleton to work with, I'll grab another blank sheet of paper and trace over that with either ink or pencil depending on the look I'm going for. Now I have a clean tracing to scan.

**4.** In a digital design program you can clean and make any last-minute refinements. Next stage, cut out the type and flourishes and separate them onto different layers. Now you can experiment with color overlays and create color compositions.

TIP A REALLY SOFT LEAD PENCIL IS A GREAT TOOL TO CREATE A FAUX CHALKBOARD LOOK BEFORE SCANNING, INVERTING THE PROJECT IN A DIGITAL DESIGN PROGRAM, AND ADJUSTING THE LEVELS.

*Step-by-step*
# POSTER DESIGN
## WITH JEFF ROGERS

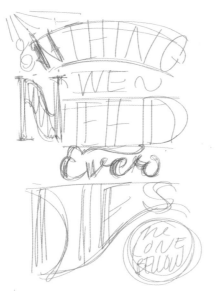

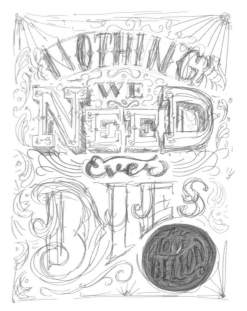

**1.** When starting a design, keep things really loose and concentrate on the composition and the general size and shape of words as opposed to specific letterforms.

**2.** Try playing with things like the scale of words, the space between letters, dialing up the ornamentation of some letters while keeping others more straightforward.

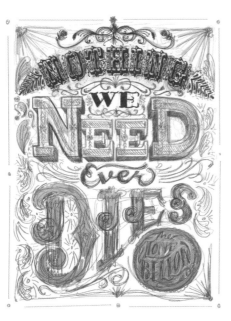

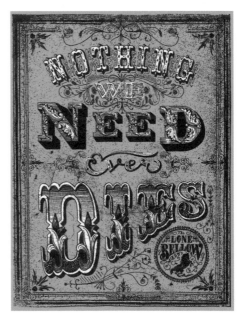

**3.** Once you settle on a composition, start refining the letterforms and build up specific details. It's all about layers and layers of refinement. If something isn't working, scrap it, and try again.

**4.** Once it was scanned into the computer, I refined all of the letterforms and flourishes, added some texture from a scanned piece of old paper, and filled in the backgrounds of the letters on a separate layer.

**TIP** USE A LIGHT-GRAY MARKER WHEN WORKING OUT COMPOSITION IDEAS AND SWITCH TO SHARPER TOOLS AS YOU REFINE.

*Step-by-step*
# MURAL DESIGN

**1.** Start by drawing out a wide grid of boxes. Use a mixture of larger and smaller shapes. These shapes will hold illustrations and lettering that pertains to our mural's chosen location—Minnesota.

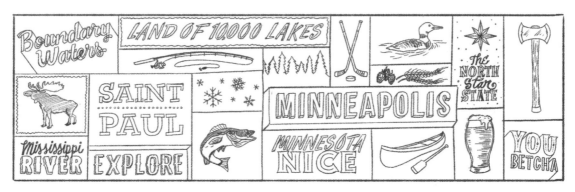

**2.** Start to plan out your composition by lightly sketching an illustration or lettering in each box. Vary up the placement of lettering and illustration to assure there is a good sense of balance across the mural.

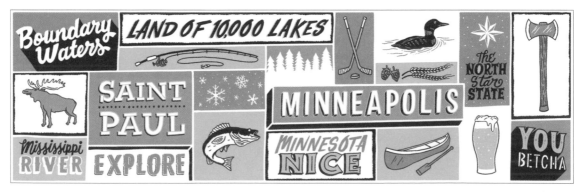

**3.** Ink your mural from left to right. If you plan on scanning the artwork onto the computer, it can help to ink portions of the mural separately and piece it all together once you have it on the computer. This will give you flexibility, particularly if the client wants an element changed. Ideally, murals should always be converted to vector points using a design program. This ensures that the mural will maintain its integrity at larger scales.

100 DAYS OF LETTERING

184

**TIP** TRY INKING YOUR MURAL IN PORTIONS AND PIECE IT TOGETHER WHEN YOU SCAN IT INTO THE COMPUTER.

# *Step-by-step*
# PRODUCT LABEL DESIGN

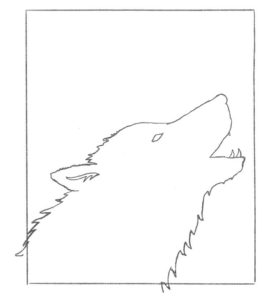

**1.** Start by drawing a simple rectangular grid, this will be the shape of your product label. Draw a howling wolf head, and keep the sketch very loose for now.

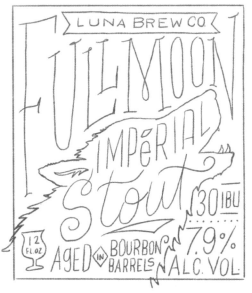

**2.** Using the rough sketch as a loose guideline, start to draw in plain lettering. Allow the lettering to surround and fill the illustration. Use a variety of complementary styles.

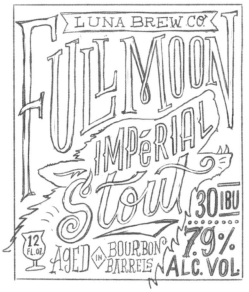

**3.** Once you're happy with your loose sketch, start to add weight and styling to your letterforms. Refine the sketch as much as possible: this will make the inking process much easier.

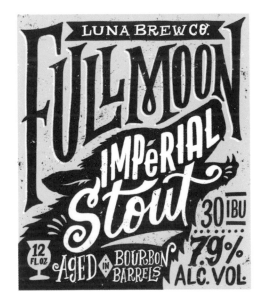

**4.** Use tracing paper to finalize your lettering with a pen, or ink directly over your sketch. Erase the sketch once the ink has dried. Take the artwork a step further and scan it into the computer for colorization.

100 DAYS OF LETTERING

 **ADDING GRITTY TEXTURE TO YOUR COMPOSITION CAN DRAMATICALLY ALTER ITS APPEARANCE. TRY IT OUT!**

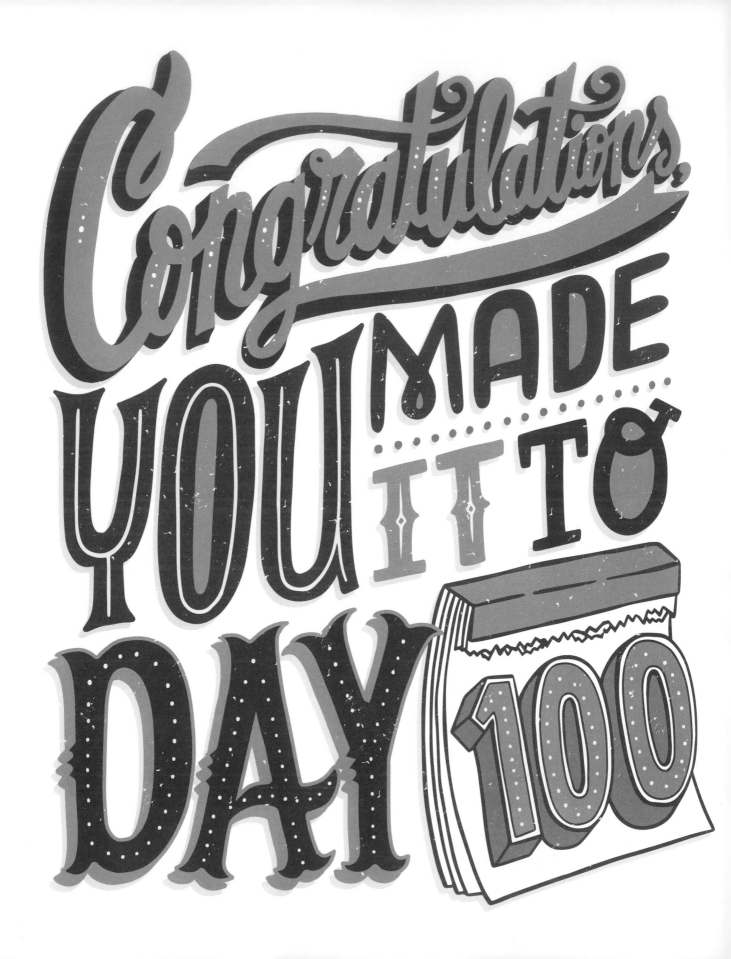

# CELEBRATE DAY 100
## BY HAND-LETTERING WHATEVER YOU WANT!

Share your final piece of artwork using
# #100DAYSOFLETTERING

# PRACTICE PAGES

Use the following practice pages to hone your lettering skills. Don't be afraid to make mistakes as you will only get better with time. Challenge yourself to fill each page with lettering styles that we've covered in this book. Happy lettering!

| A | B | C | D | E | F |
|---|---|---|---|---|---|
|   |   |   |   |   |   |

| G | H | I | J | K | L | M |
|---|---|---|---|---|---|---|
|   |   |   |   |   |   |   |

| N | O | P | Q | R | S |
|---|---|---|---|---|---|
|   |   |   |   |   |   |

| T | U | V | W | X | Y | Z |
|---|---|---|---|---|---|---|
|   |   |   |   |   |   |   |

| & | ? | ! | , | ' | : |
|---|---|---|---|---|---|
|   |   |   |   |   |   |

# ABOUT THE AUTHOR

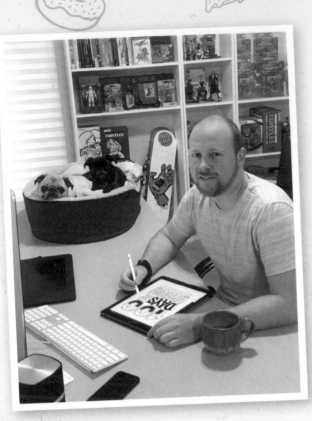

Jay Roeder is a hand-lettering artist and illustrator based in Connecticut. He works in a studio out of his home along with his pugs who sit on his desk, while he procrastinates, drinks coffee, and does work, sometimes. Jay graduated from Sacred Heart University in 2006 with a double major in graphic design and illustration. He started his career at several of the top agencies in the country, establishing a solid foundation of knowledge and skill sets before going out on his own in 2011.

Jay's work has been featured and sold by companies such as Nike, GAP, Hilton, American Greetings, Ray-Ban, Mental Floss, and Facebook. His style blends playful lettering with retro thematics and bumper sticker humor. *100 Days of Lettering* is Jay's first book.

To learn more about Jay and his current projects, visit his site or follow him on social media:

**JAYROEDER.COM** | **@JAYROEDER**

# ACKNOWLEDGMENTS

It has been a goal of mine for a long time to author my own book, but I wouldn't be in this position without the support and guidance of many different people along the way. I would like to thank the following people who helped make *100 Days of Lettering* possible:

Lark Crafts and BlueRed Press, for believing in me and weaving everything together to make my dream a reality. I am so proud of what we have done.

Nikki, for being the most unbelievable wife a guy could ask for. You make sitting around in sweatpants and watching horrible natural disaster movies and murder mysteries enjoyable. I look forward to many more years of sushi and travel with you. I love you.

Mom, for always encouraging me to dance. You have always pushed me to pursue my creative passions, and as a result I have made a career out of it. I am truly happy, and you have a lot to do with that.

Dad, for always believing in me. When I contemplated going out on my own you were behind me from day one. I have always confided in you for personal and career advice, and I want to thank you for that.

Chris and Andy, this book is dedicated to the two of you because the experiences we've shared are the sources of so much of my creative inspiration. Not only are you my brothers, but also my best friends.